BALLET

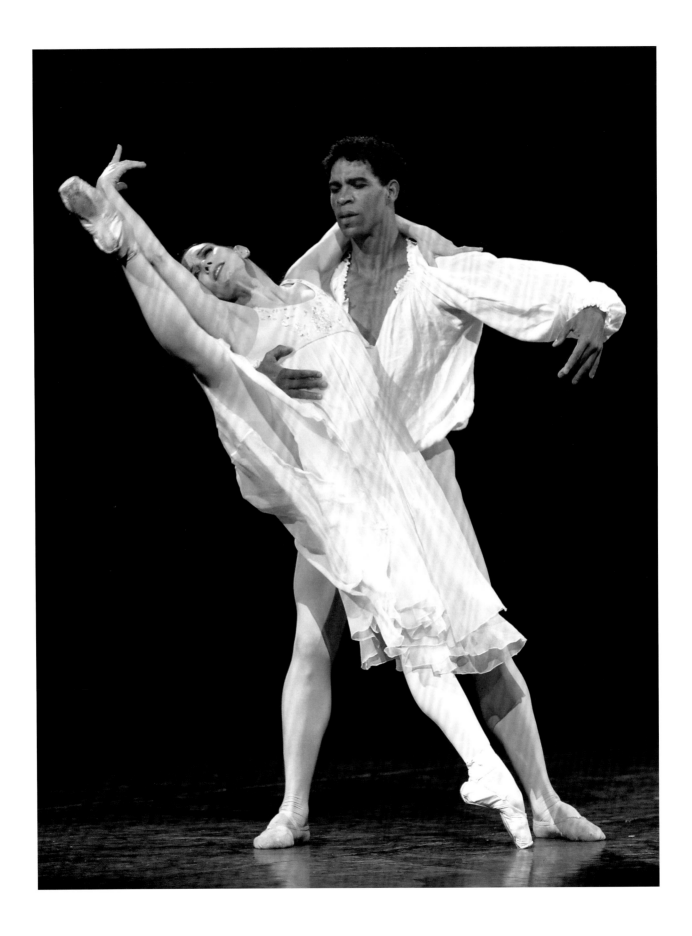

BALLET

Leo Mason

AMMONITE
PRESS

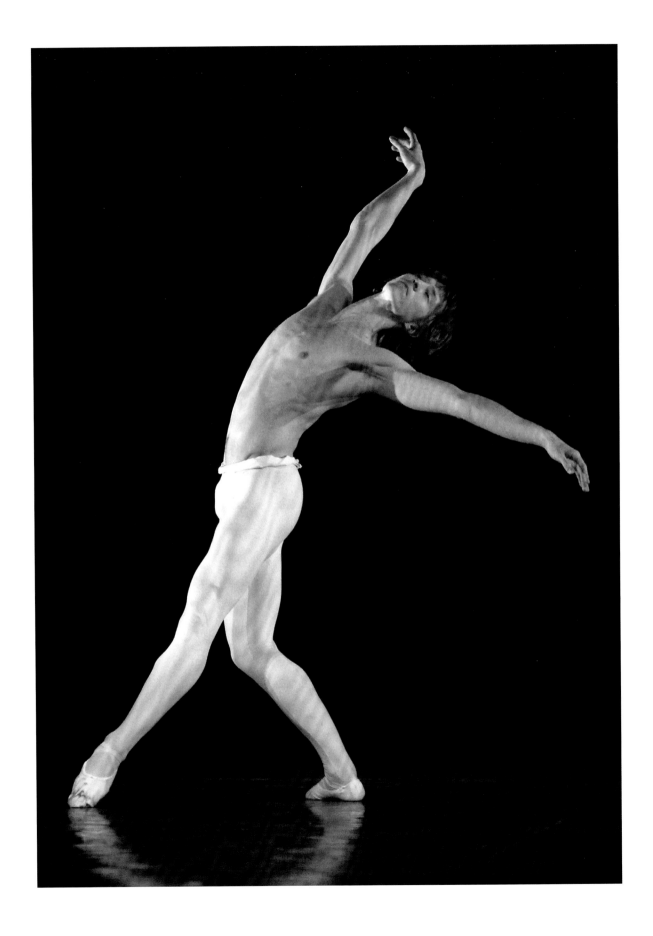

contents

Introduction **6**

The ballets **10**

Technical details **178**

Index **187**

About the author **190**

Acknowledgements **190**

The author would like to thank the following for the opportunity to photograph the ballets and dancers at the photocalls featured in this book:

The Australian Ballet, Barbican Theatre (London), The Bolshoi Ballet, Dutch National Ballet, Eifman Ballet, English National Ballet, Les Ballets de Monte Carlo, London Coliseum, The Mariinsky Ballet, Milton Keynes Theatre, Dada Masilo, New Adventures, Ivan Putrov, Queensland Ballet, Royal Albert Hall (London), Royal Ballet Flanders, Royal Opera House (London), Sadler's Wells (London), and St Petersburg Ballet Theatre.

introduction

One day, back in 2009, my agency editor called me . . .

"Hi Leo, our dance photographer has just rung with a problem, could you help us out and shoot tonight's photo call at Sadler's Wells?"

"I've never shot dance before," I replied. "Well, just do the best you can."

The advice my friend John Claridge gave to me when I started out ran through my head, "Remember Leo, you are there to record what you see for those of us that can't be there." So, with those wise words still resonating, I turned up at Sadler's Wells that evening to shoot my first ballet.

The next day, my editor called to say: "You're unknown and made three national newspapers today! Do you fancy giving up the day job of shooting sports?"

Very soon after that first shoot at Sadler's Wells, I started to get invitations to other productions at the Royal Opera House in Covent Garden, the London Coliseum, the Peacock Theatre and other theatres in the UK. As a result, I was fortunate to work with the world's top ballet dancers.

Up until that point, however, my life as a professional photographer had been in advertising, and then top level sports with magazines and newspapers such as *Time*, *USA Today* and *Sports Illustrated*; the world of dance and theatres was very different. There was a very small group of specialist dance and theatre photographers, all of whom had started shooting on film which, given the low levels lighting at the time, must have been very challenging. But despite me being a total stranger, the group accepted me, and they were extremely helpful with explaining the nuances of dance.

'A ballet is a picture, or rather a series of pictures connected one with the other by the plot.'
—JEAN-GEORGES NOVERRE

When I started shooting ballet, I soon began to see some visual similarities with the sports I had photographed – dance is also a combination of movement and athleticism, but with the addition of the interpretation of the music in the choreography. As I listened to the music I was able to better read the dancers body language in order to capture the grace of their performances. Furthermore, at certain points I found could use the multiple exposure technique that I used in my sports photography to capture the complex and technically demanding sequences that the dancers performed, never more so than when they were moving perfectly en pointe or jumping (for example, see page 15).

As the years progressed, I began to get direct commissions from the companies which involved shooting live performances. So as to not disturb the audience, I used a soundproof cover over my camera (nowadays we all use silent, mirrorless cameras). I generally shot from the sound engineer's station halfway up in the stalls.

While putting this book together I remembered back to when I lived in St Martin's Lane with my wife, and we would go to the Coliseum (just across the street), the Royal Opera House and Sadler's Wells to enjoy all the ballets. One of the first ballets we saw together was Wayne Sleep in *Romeo and Juliet*. Many years later I sat in almost the same seat during a photo dress rehearsal for the same show and I reflected on what a greatly privileged life it was to be a photographer and how, almost by fate, I now sat alone with my camera in this beautiful theatre, watching some of the greatest dancers in the modern era and listening to the wonderful live orchestra.

I hope that as you marvel at the incredibly creative artists featured in this book, you can share my enjoyment of these extraordinary ballets.

RIGHT
Andressa Corso and Grey Araújo in
Rodrigo Pederneiras's *Parabelo*, performed
by Grupo Corpo at Sadler's Wells, London
1 October 2014

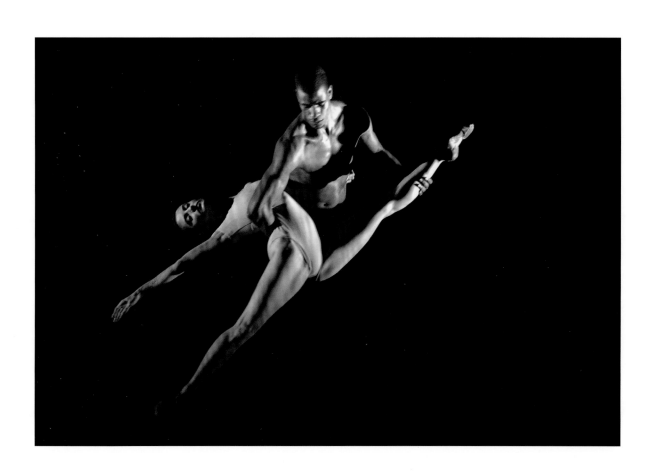

The ballets

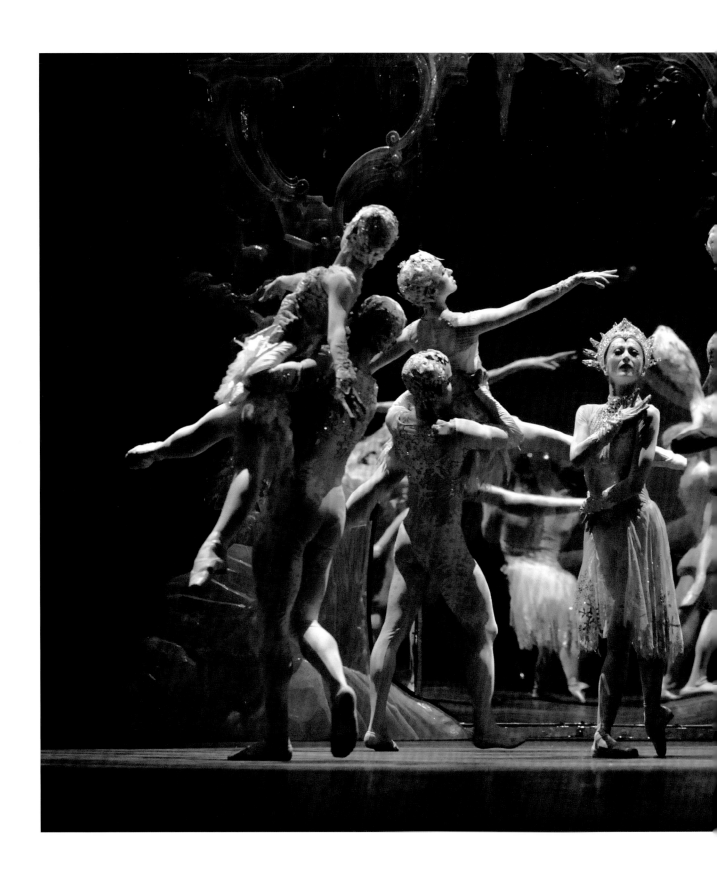

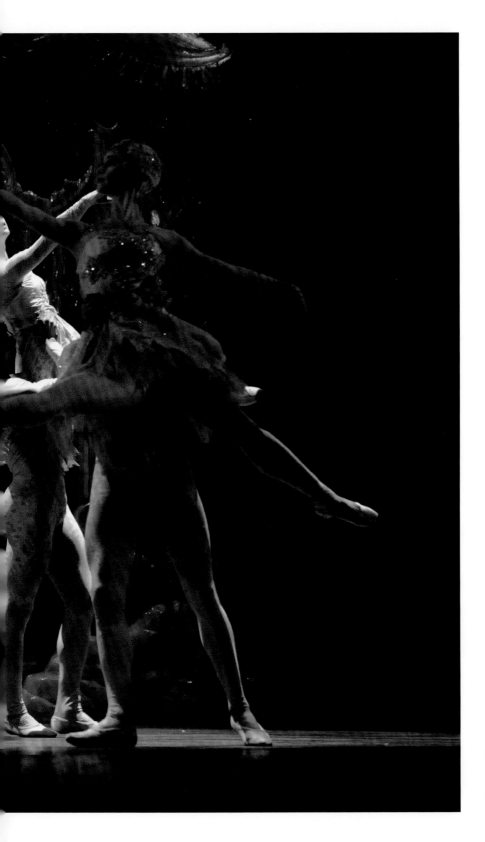

RIGHT
Daria Klimentová in Michael Corder's
The Snow Queen, performed by English
National Ballet at the London Coliseum
7 January 2010

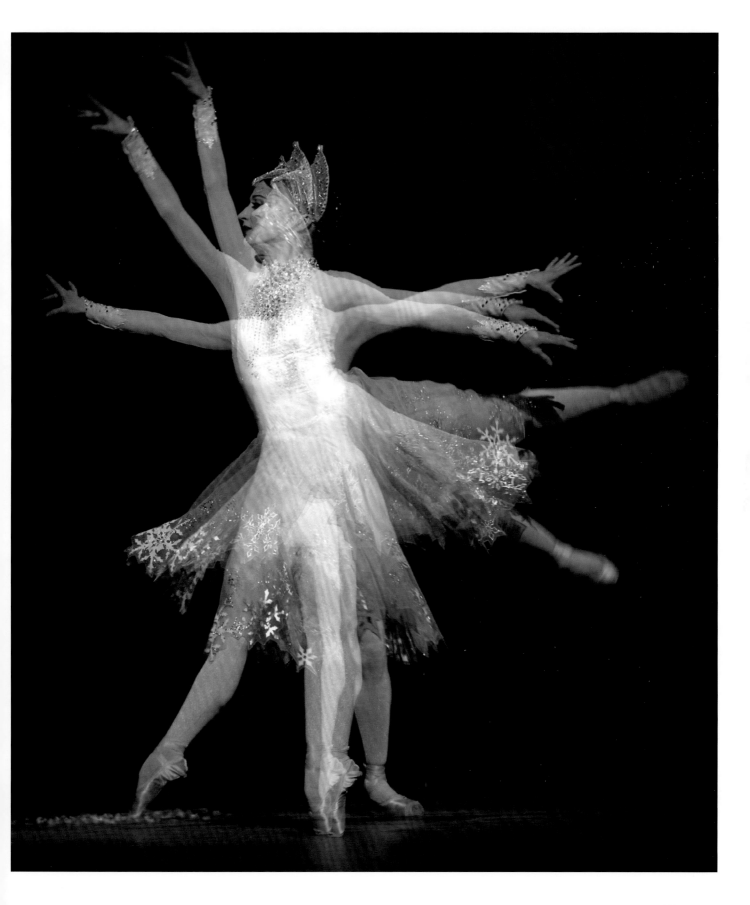

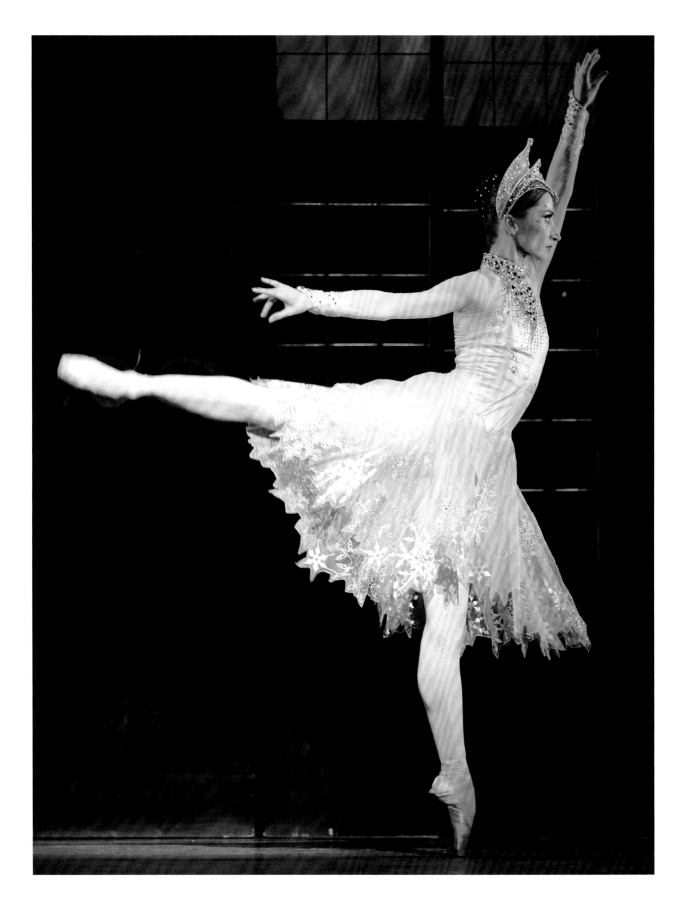

LEFT
Daria Klimentová in Michael Corder's
The Snow Queen, performed by English
National Ballet at the London Coliseum
7 January 2010

Daniel Kraus in Wayne Eagling's
Men Y Men, performed by English
National Ballet at the London Coliseum
20 January 2010

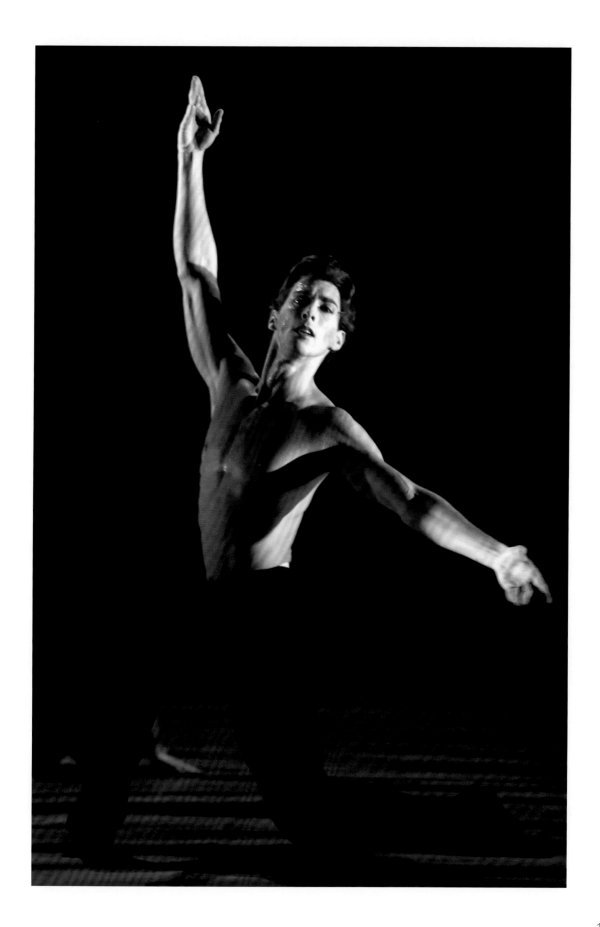

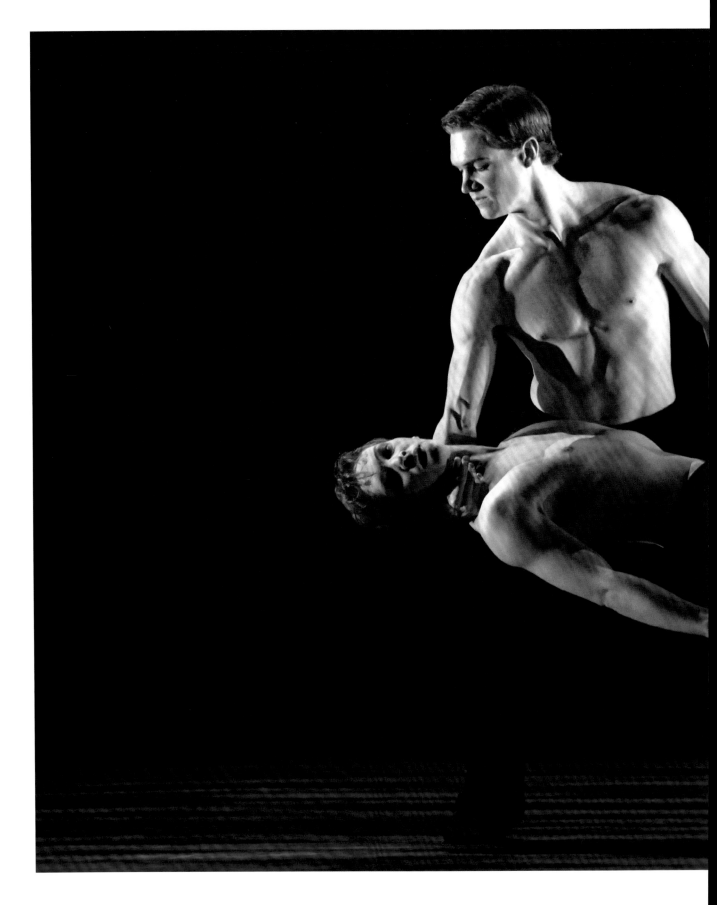

LEFT
**Max Westwell and Anton
Lukovkin** in Wayne Eagling's *Men Y
Men*, performed by English National
Ballet at the London Coliseum
20 January 2010

**Vadim Muntagirov and Daria
Klimentová** in Rudolf Nureyev's
Romeo and Juliet, performed
by English National Ballet at the
London Coliseum
4 January 2011

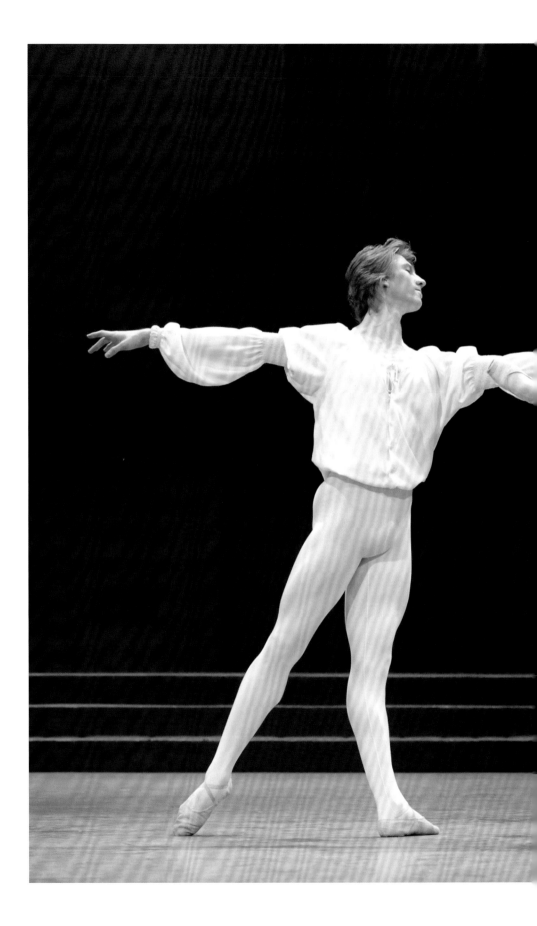

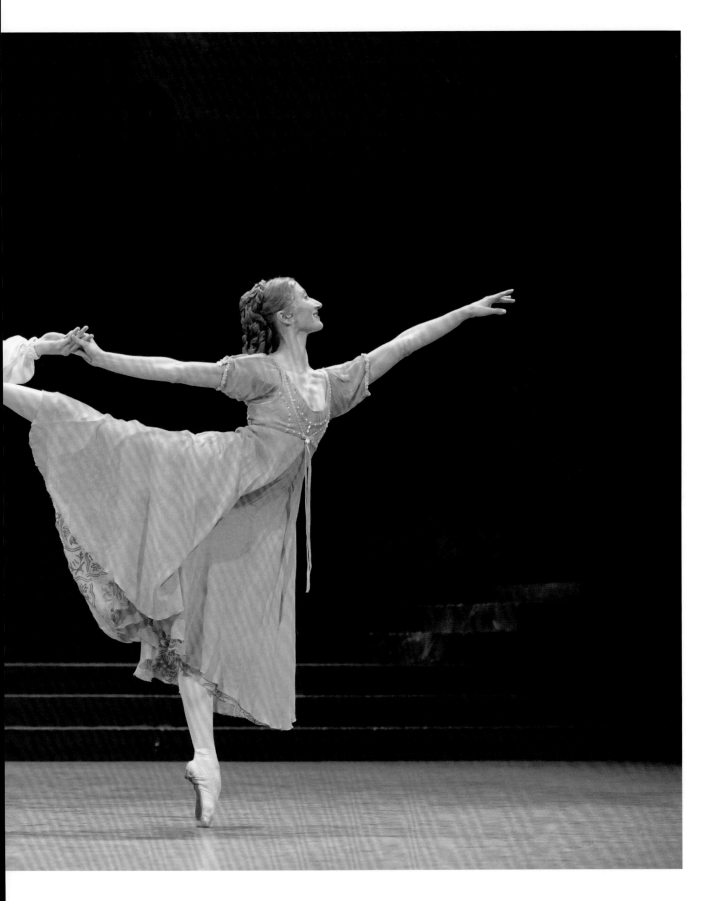

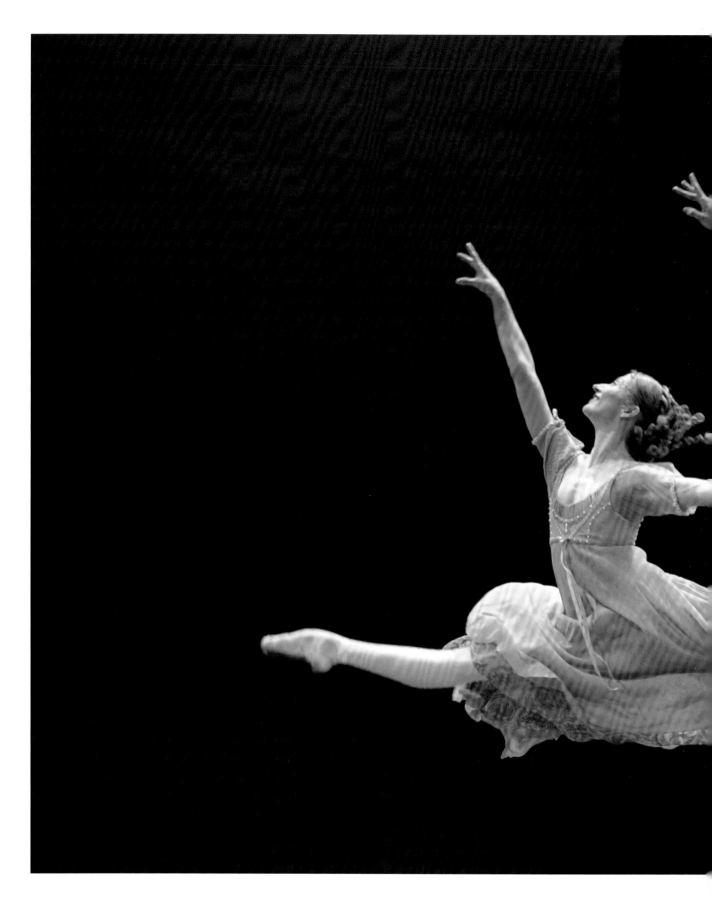

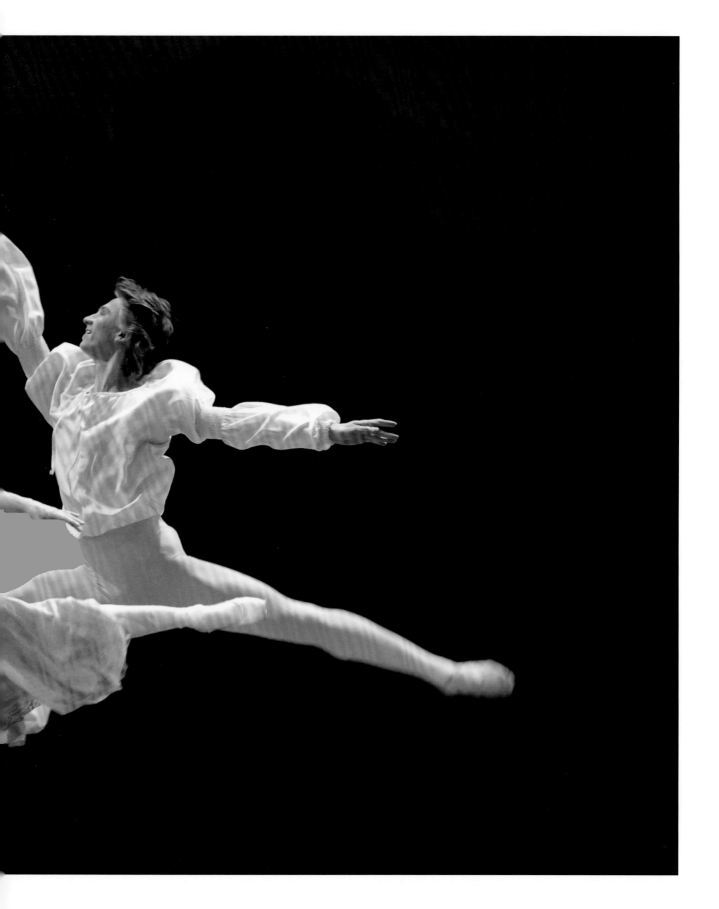

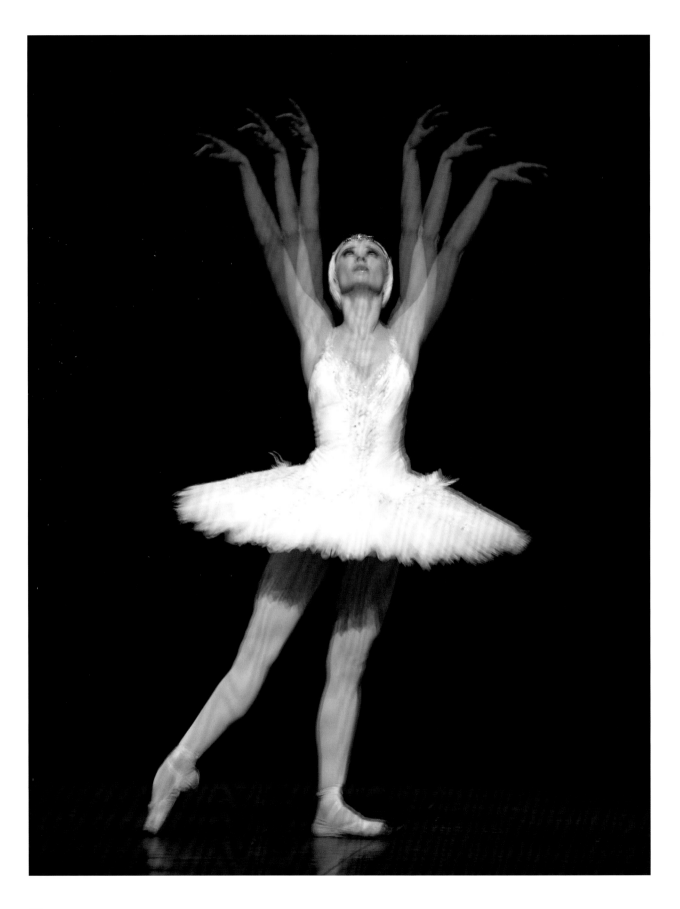

LEFT
Daria Klimentová in Derek Deane's *Swan Lake*, performed by English National Ballet at the London Coliseum
22 March 2011

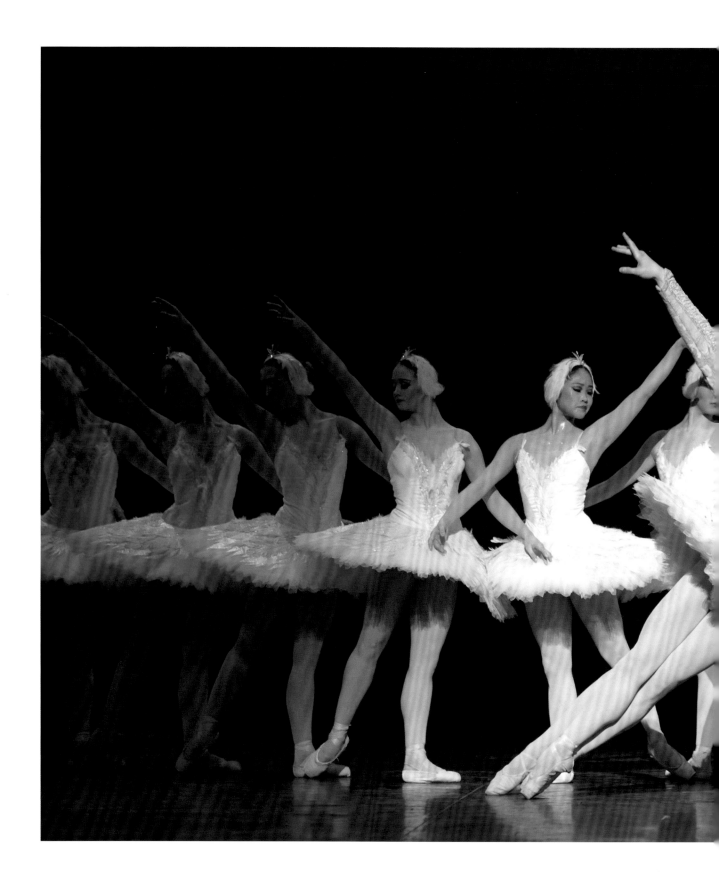

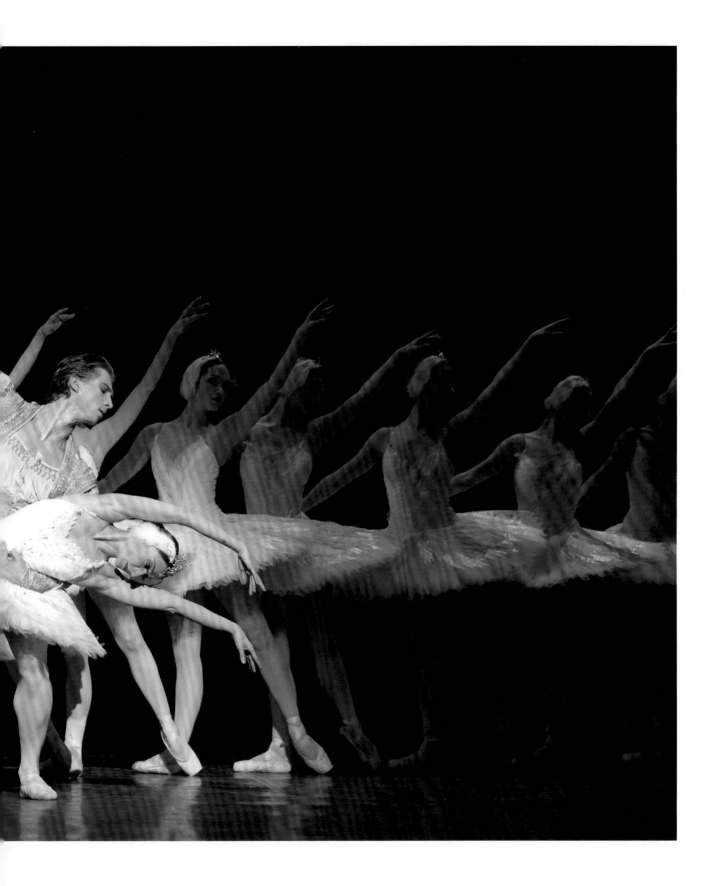

Vadim Muntagirov and Daria Klimentová
in Derek Deane's *Swan Lake*, performed by
English National Ballet at the London Coliseum
22 March 2011

'Dancing is creating a sculpture that is visible only for a moment.'

—EROL OZAN

RIGHT
Daria Klimentová in Derek Deane's
Swan Lake, performed by English
National Ballet at the London Coliseum
22 March 2011

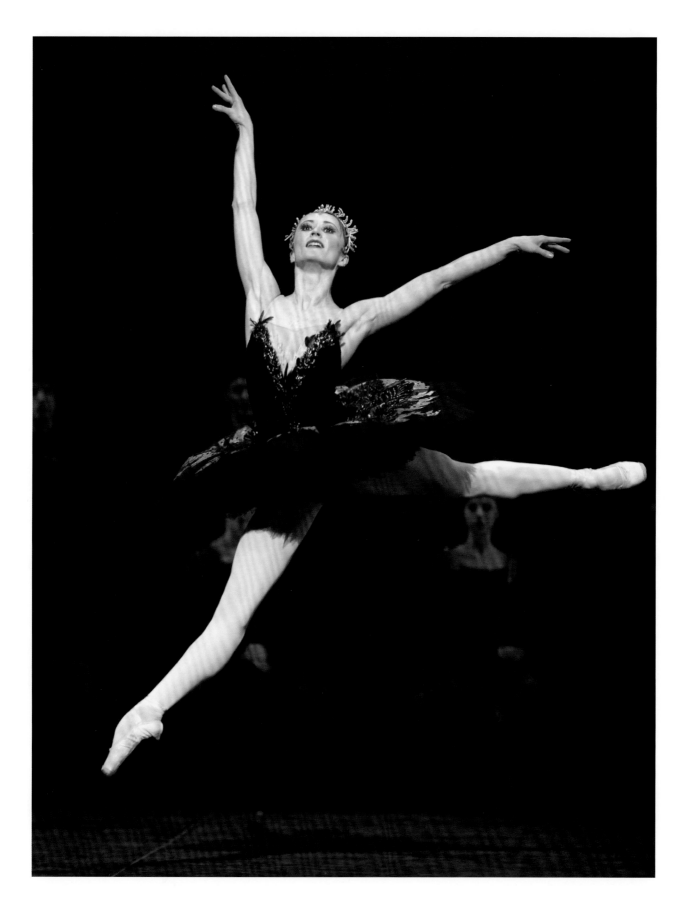

RIGHT
Igone de Jongh and Matthew Golding
in Hans van Manen's *Grosse Fuge*,
from Hans van Manen – Master of Dance,
performed by Dutch National Ballet at
Sadler's Wells, London
12 May 2011

34

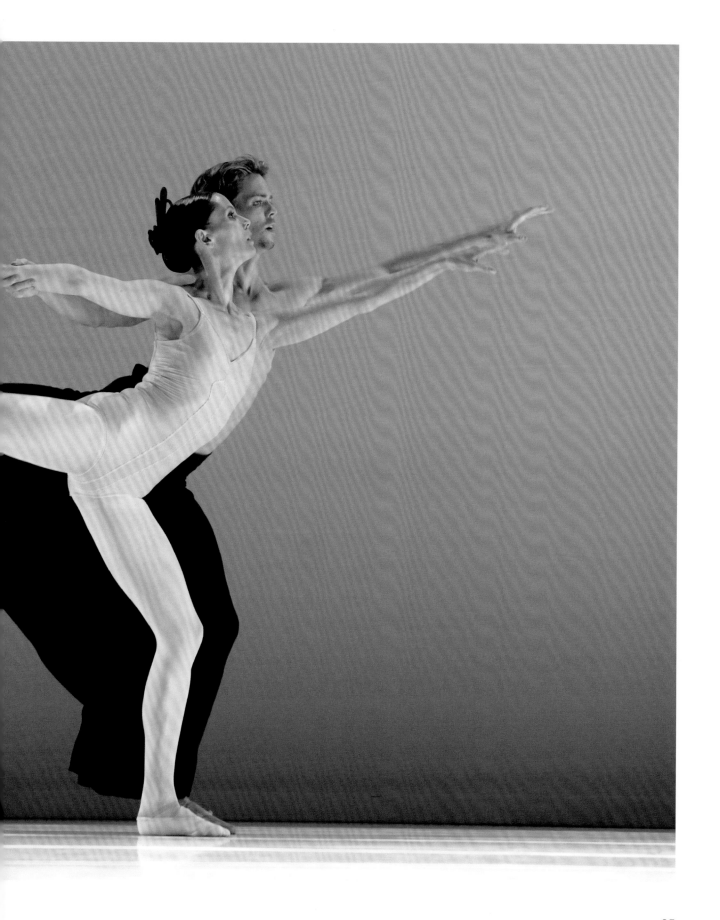

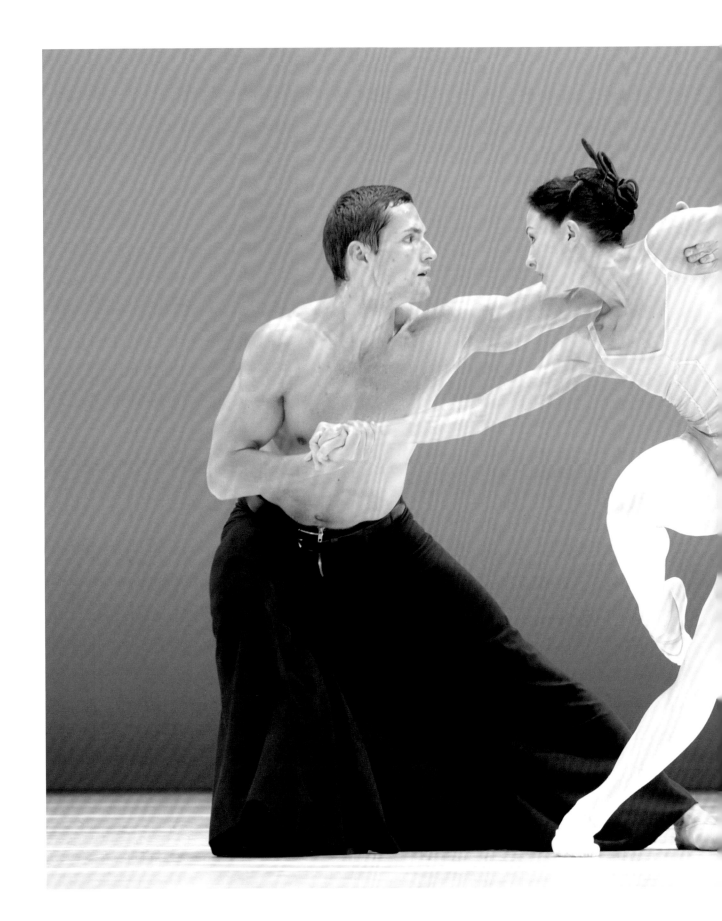

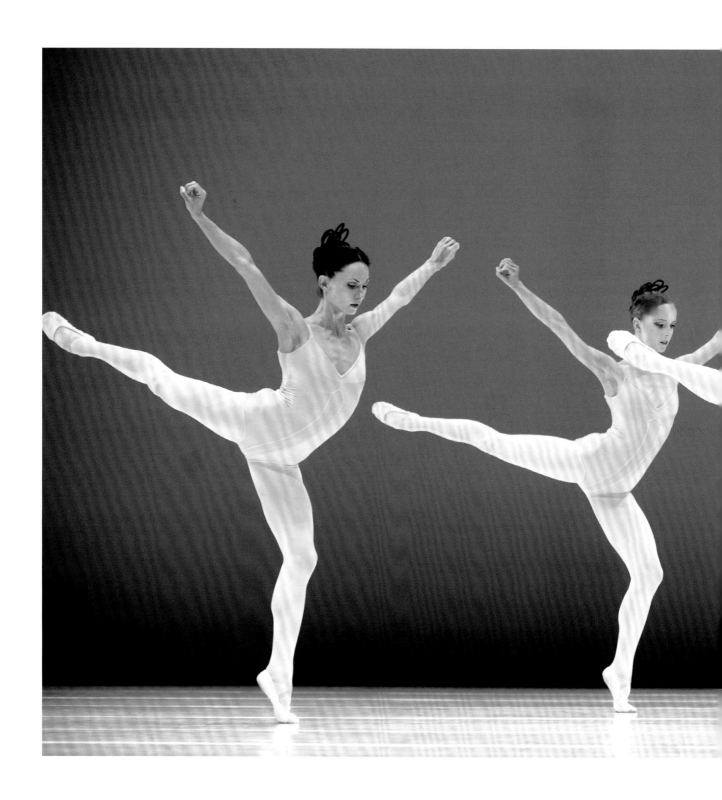

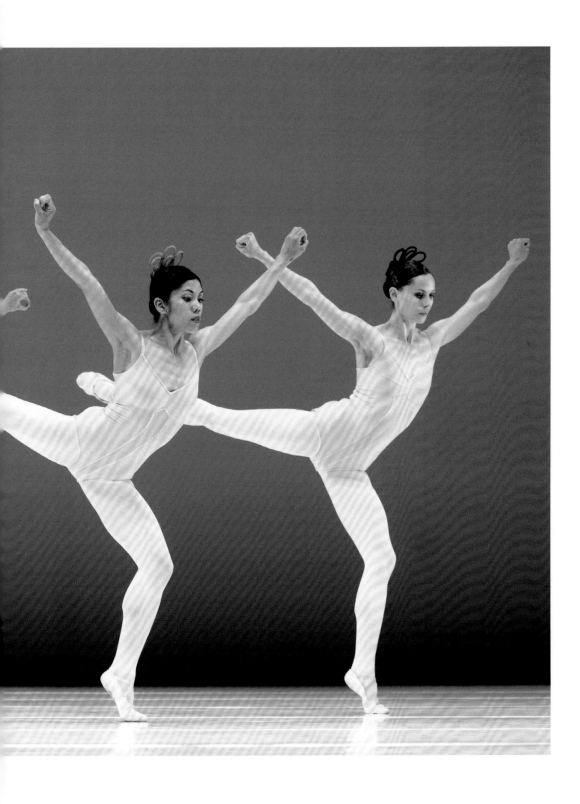

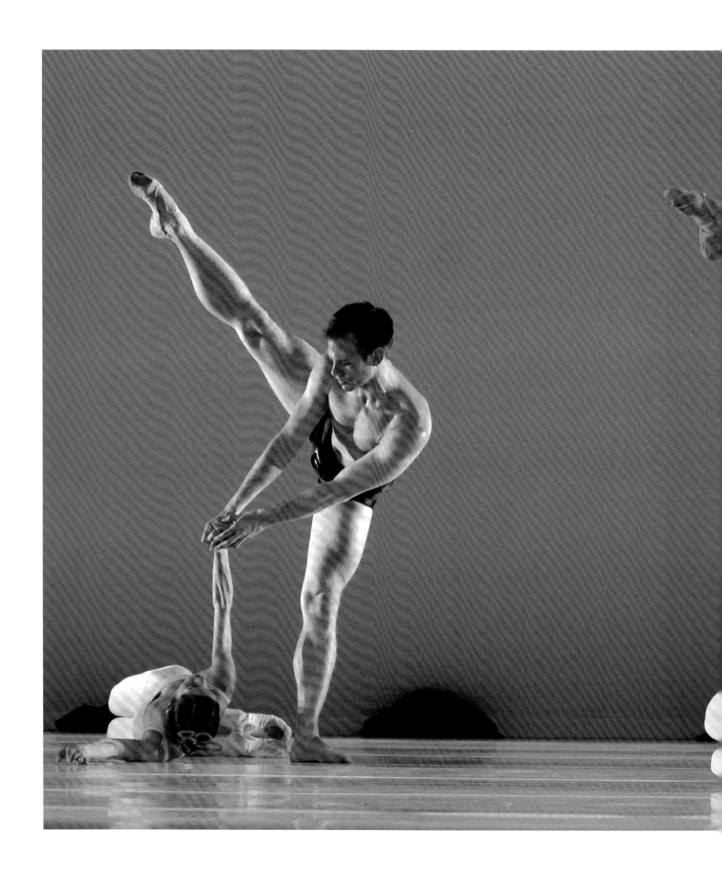

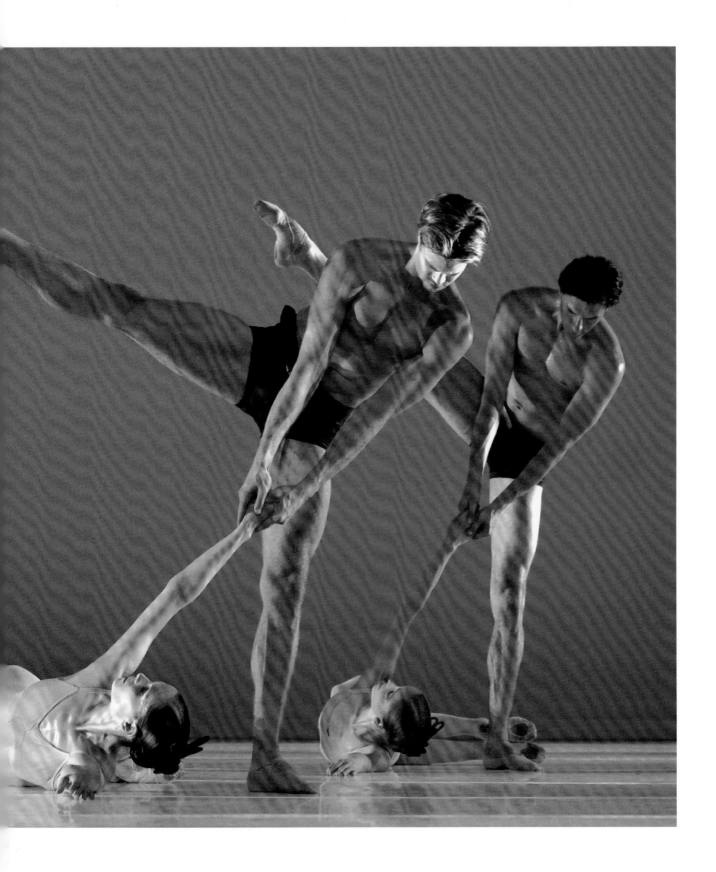

PRECEDING PAGES
**Marisa Lopez, Cedric Ygnace,
Igone de Jongh, Matthew Golding,
Anu Viheriäranta and Jozef Varga**
in Hans van Manen's *Grosse Fuge*,
from Hans van Manen – Master of Dance,
performed by Dutch National Ballet at
Sadler's Wells, London
12 May 2011

RIGHT
Ivan Vasiliev and Natalia Osipova in
Sir Frederick Ashton's *Romeo and Juliet*,
performed by the Bolshoi Ballet at the
London Coliseum
11 July 2011

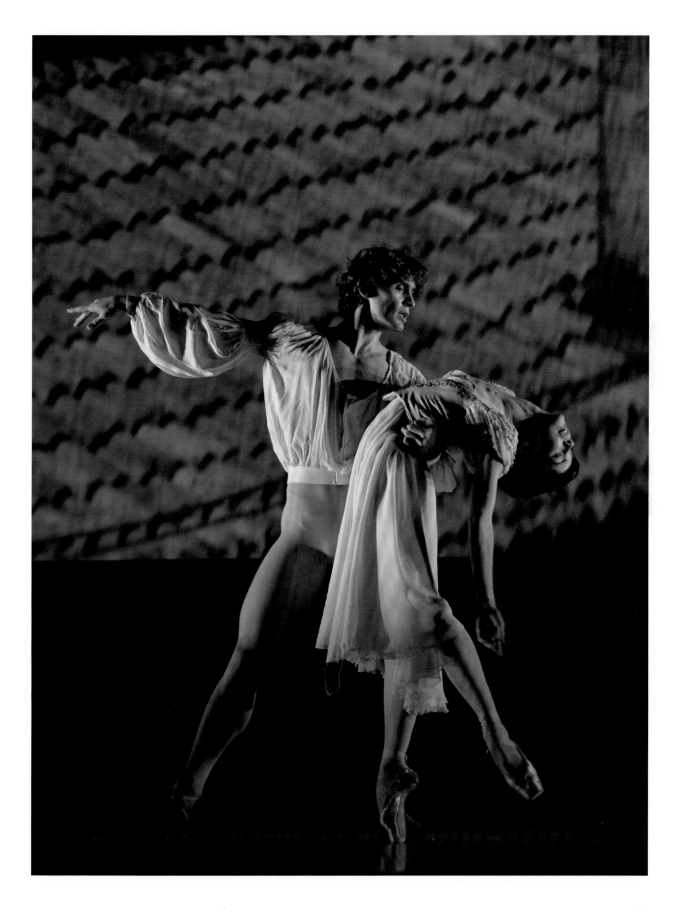

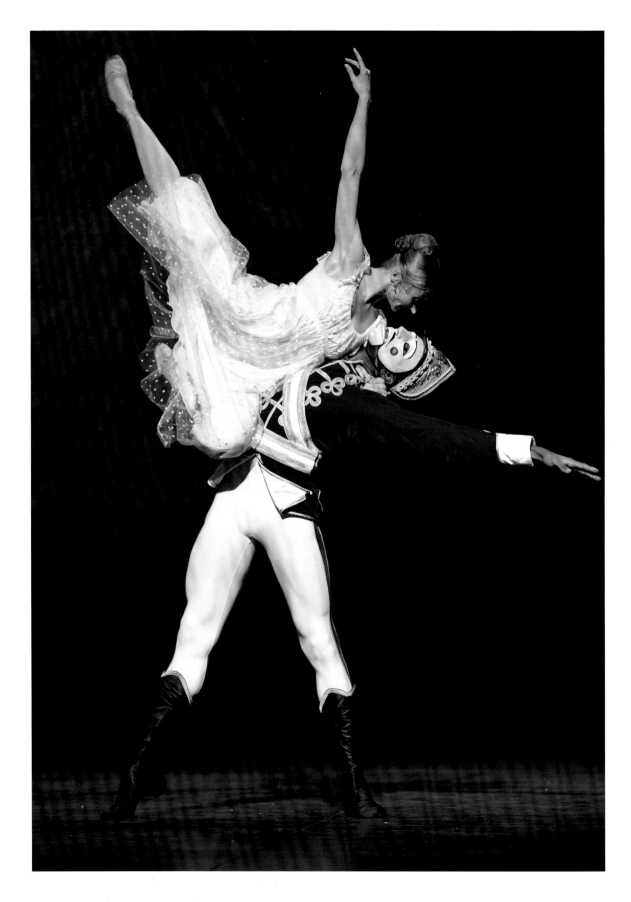

LEFT
Daria Klimentová and Junor Souza
in Wayne Eagling's *Nutcracker*,
performed by English National Ballet
at the London Coliseum
7 December 2011

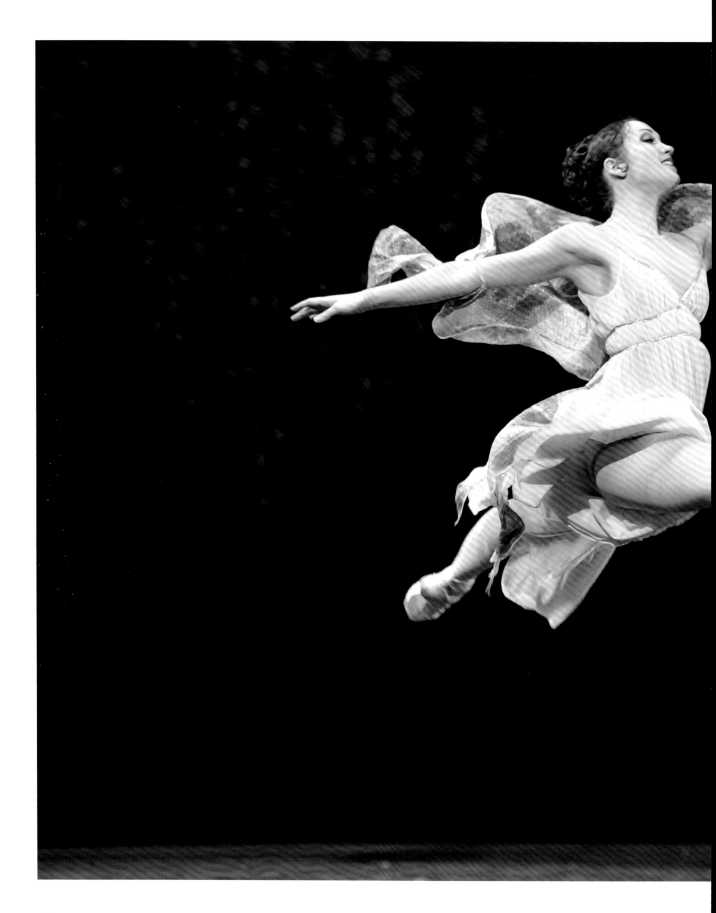

LEFT
Ksenia Ovsyanick in Wayne Eagling's
Nutcracker, performed by English National
Ballet at the London Coliseum
7 December 2011

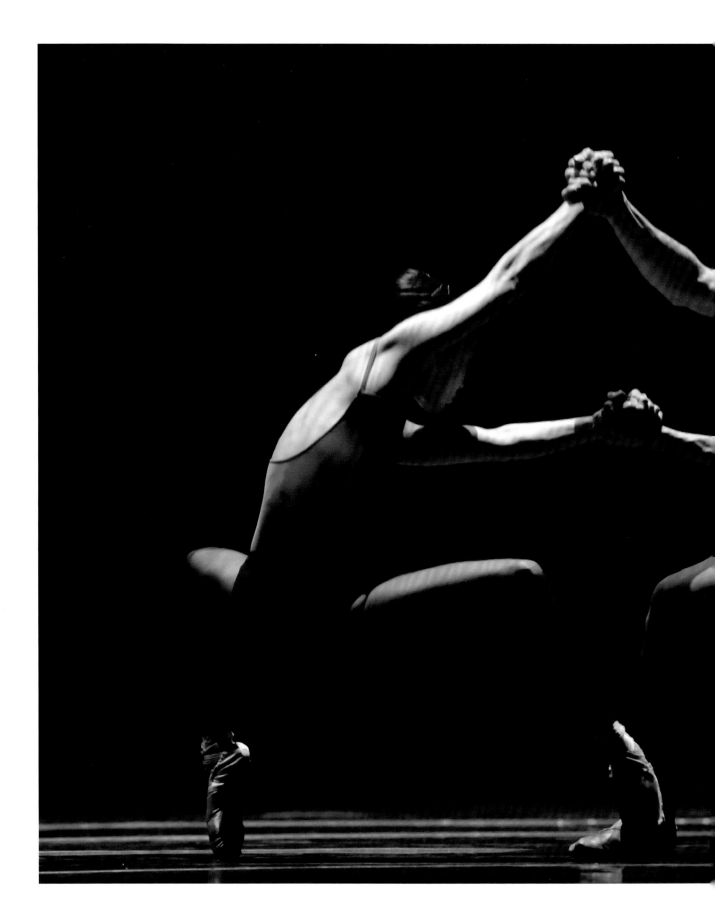

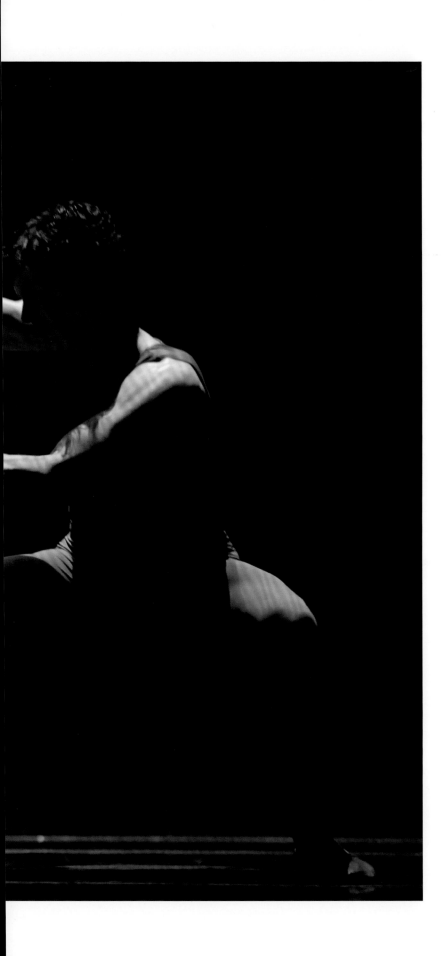

LEFT
Aki Saito and Wim Vanlessen in William
Forsythe's *Artifact*, performed by Royal Ballet
Flanders at Sadler's Wells, London
18 April 2012

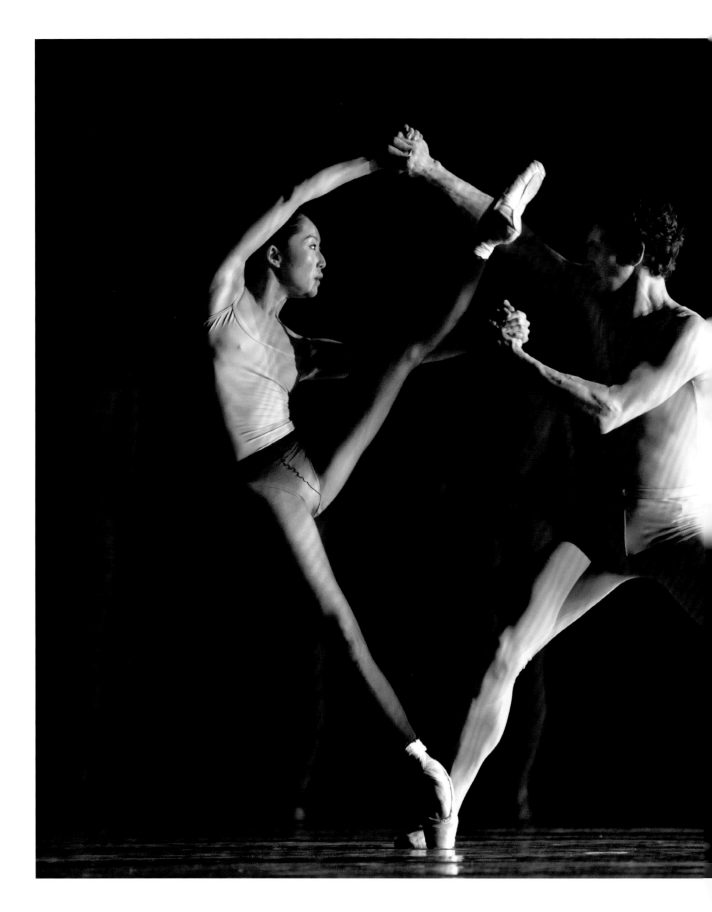

LEFT
Aki Saito and Wim Vanlessen in William
Forsythe's *Artifact*, performed by Royal Ballet
Flanders at Sadler's Wells, London
18 April 2012

RIGHT
Tamara Rojo and Daria Klimentová
in Sir Kenneth MacMillan's *The Sleeping Beauty*, performed by English National Ballet at Milton Keynes Theatre
16 October 2012

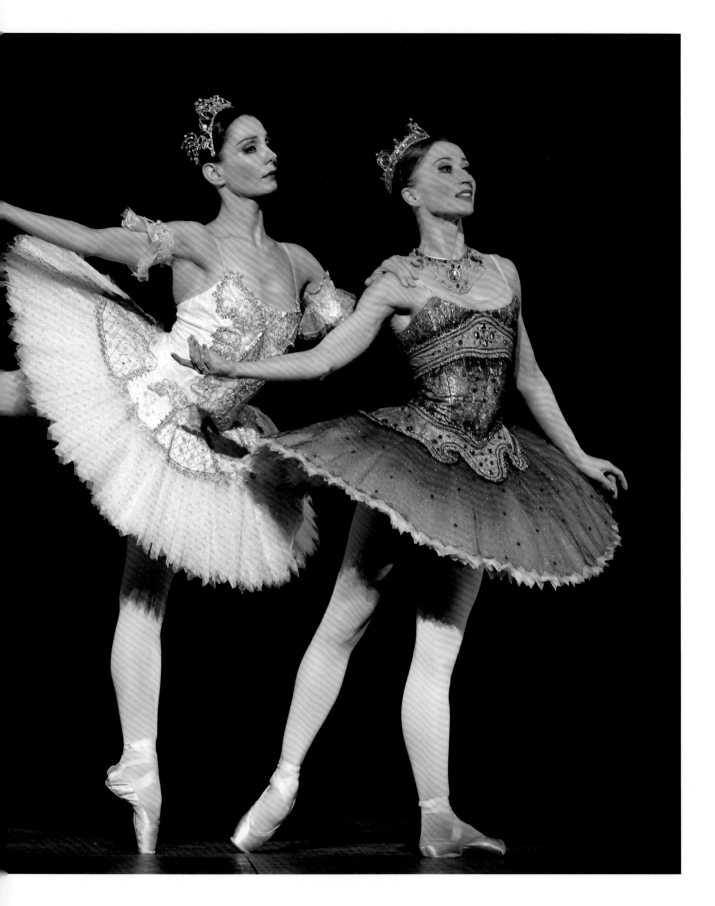

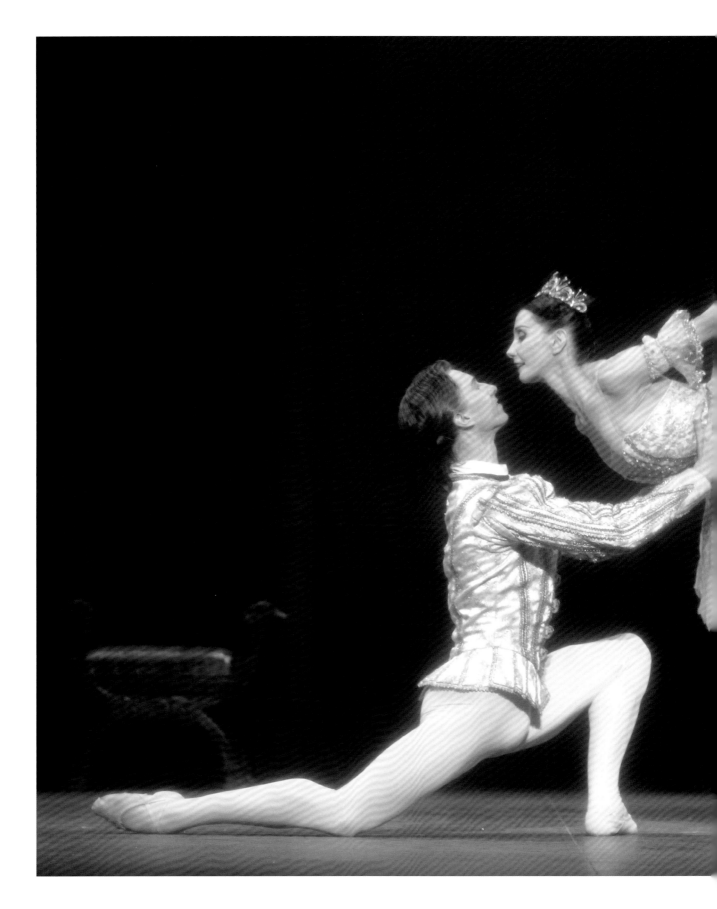

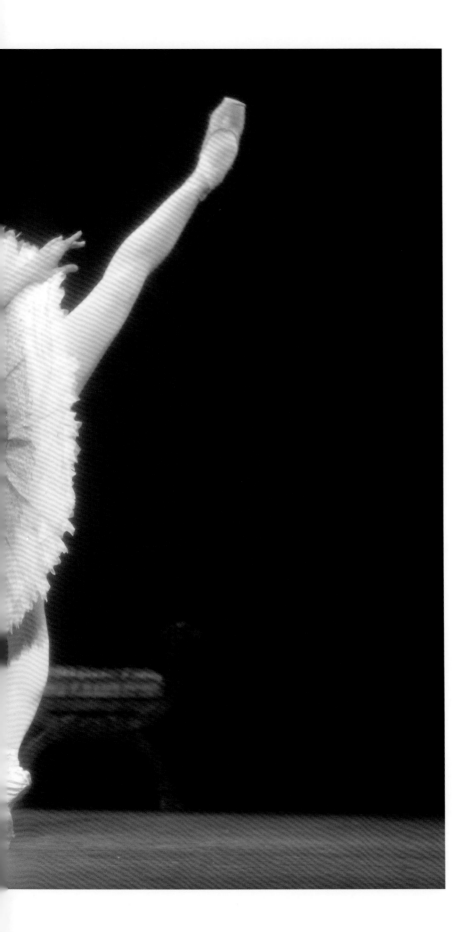

LEFT
Vadim Muntagirov and Tamara Rojo
in Sir Kenneth MacMillan's *The Sleeping
Beauty*, performed by English National
Ballet at Milton Keynes Theatre
16 October 2012

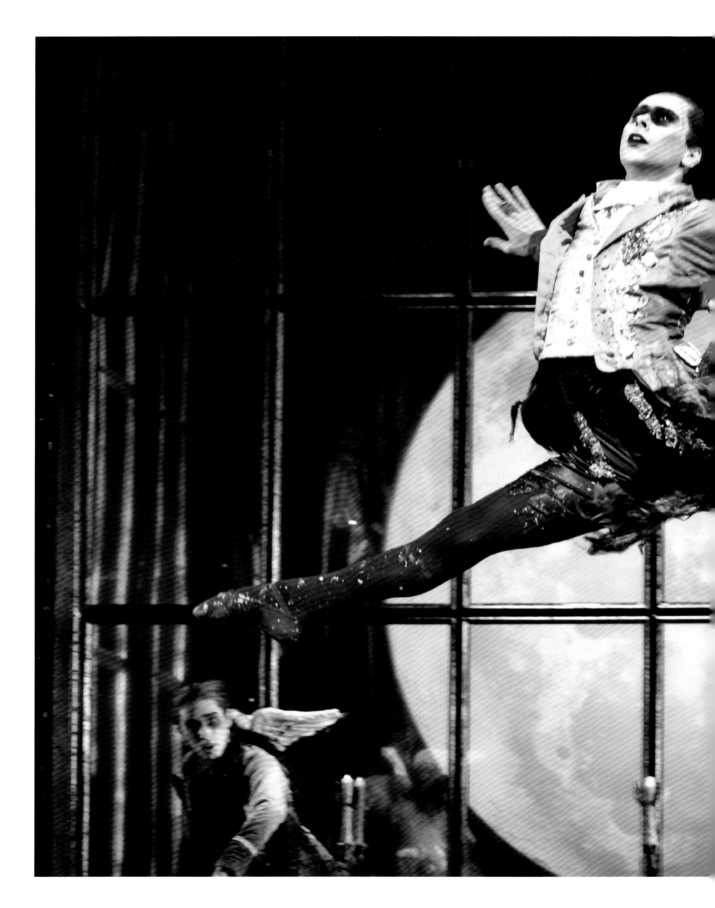

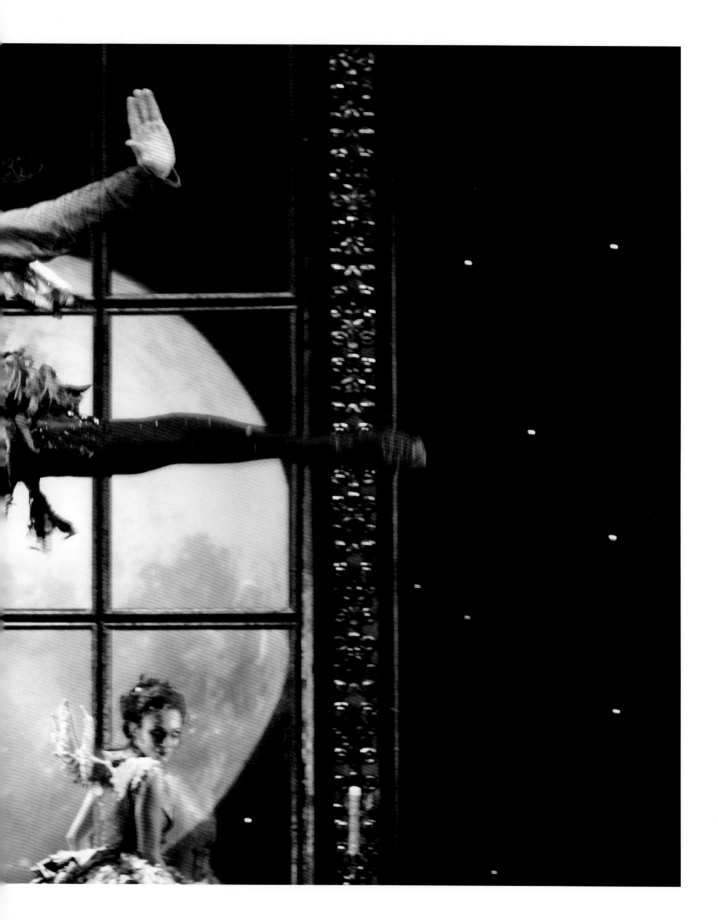

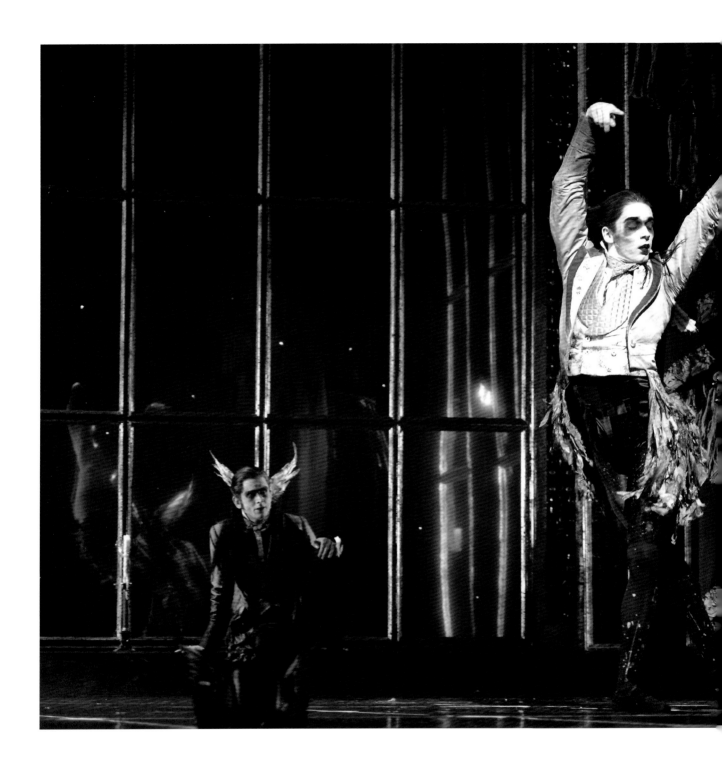

PRECEDING PAGES
Christopher Marney in Matthew Bourne's
Sleeping Beauty, performed by New
Adventures at Sadler's Wells, London
7 December 2012

ABOVE
Liam Mower in Matthew Bourne's *Sleeping
Beauty*, performed by New Adventures at
Sadler's Wells, London
7 December 2012

58

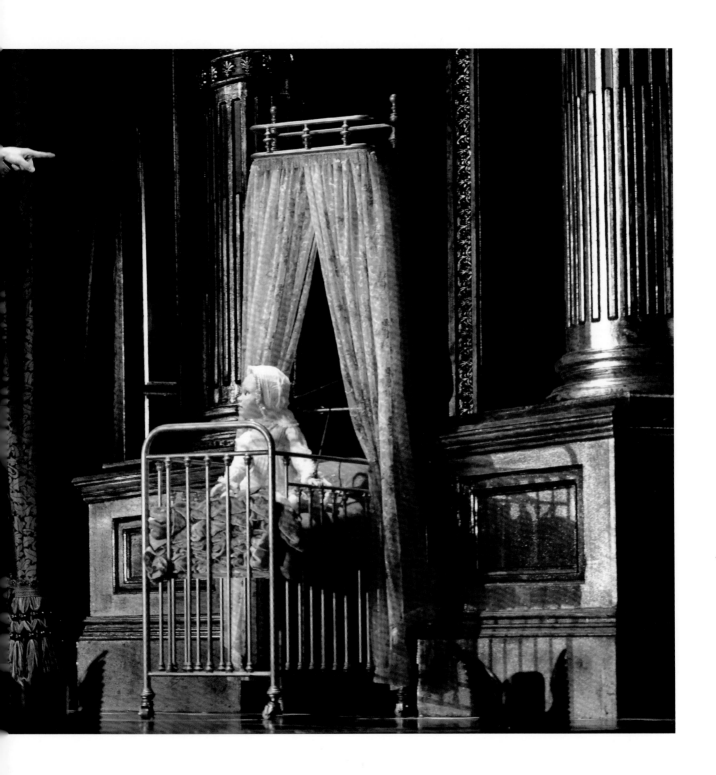

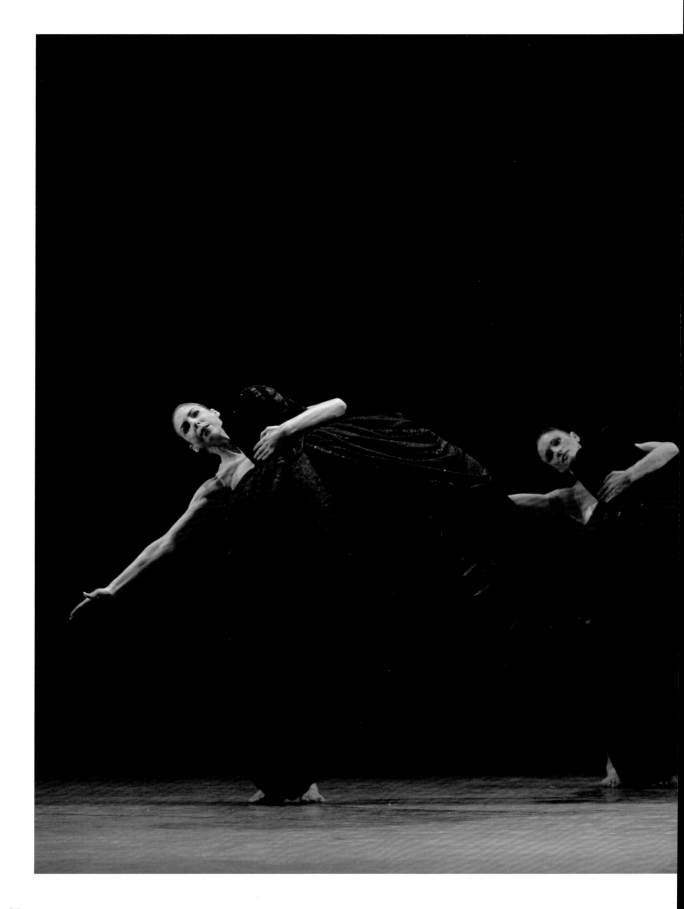

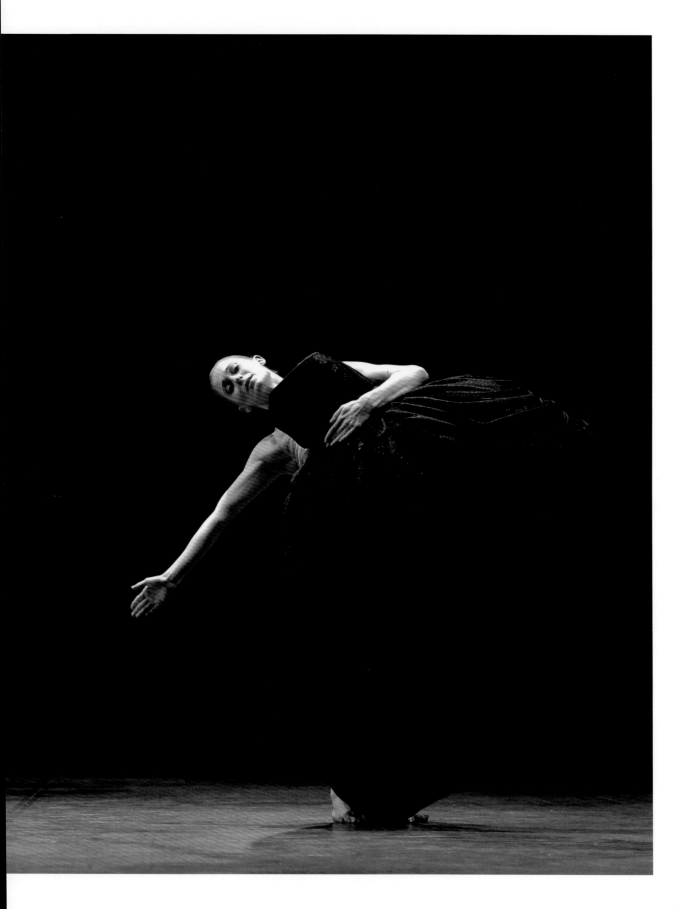

PRECEDING PAGES
Jiří Kylián's *Petite Mort*, part of Ecstasy and
Death, performed by English National Ballet
at the London Coliseum
17 April 2013

FOLLOWING PAGES
James Forbat and Ksenia Ovsyanick in
Jiří Kylián's *Petite Mort*, part of Ecstasy and
Death, performed by English National Ballet
at the London Coliseum
17 April 2013

'The important thing in ballet is the movement itself. A ballet may contain a story, but the visual spectacle . . . is the essential element. The choreographer and the dancer must remember that they reach the audience through the eye. It's the illusion created that convinces the audience much as it is the work of a magician.'

—GEORGE BALANCHINE

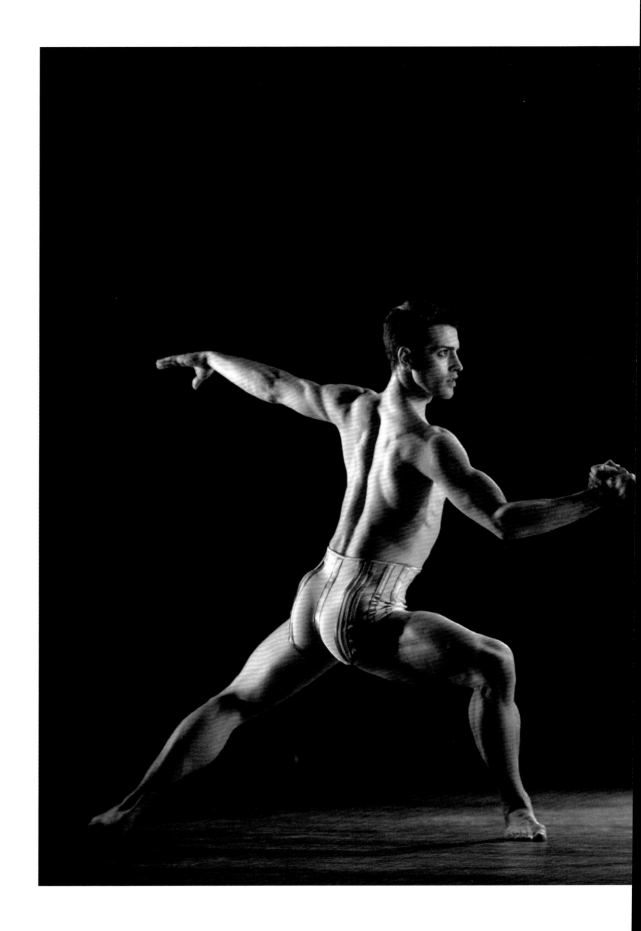

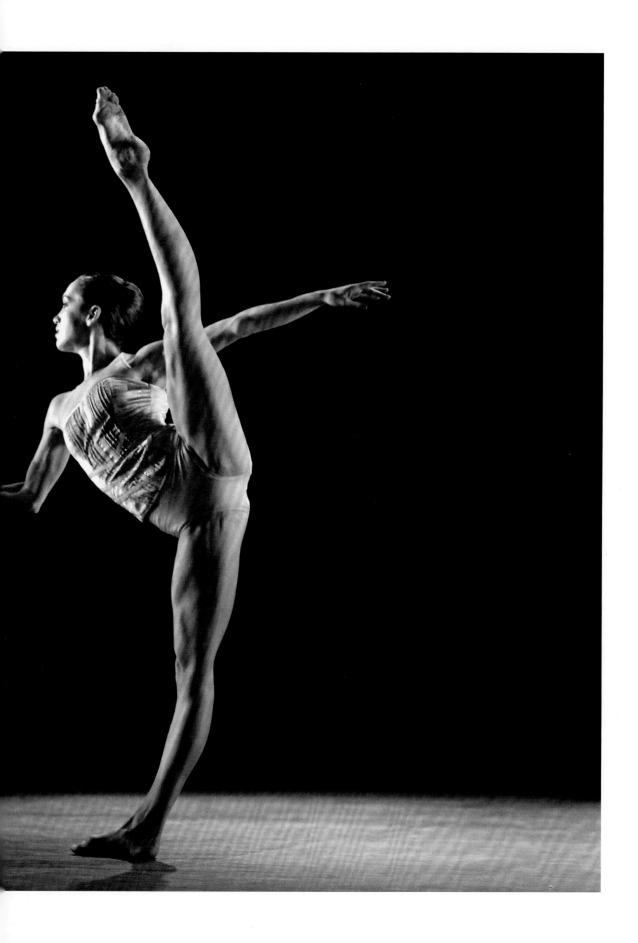

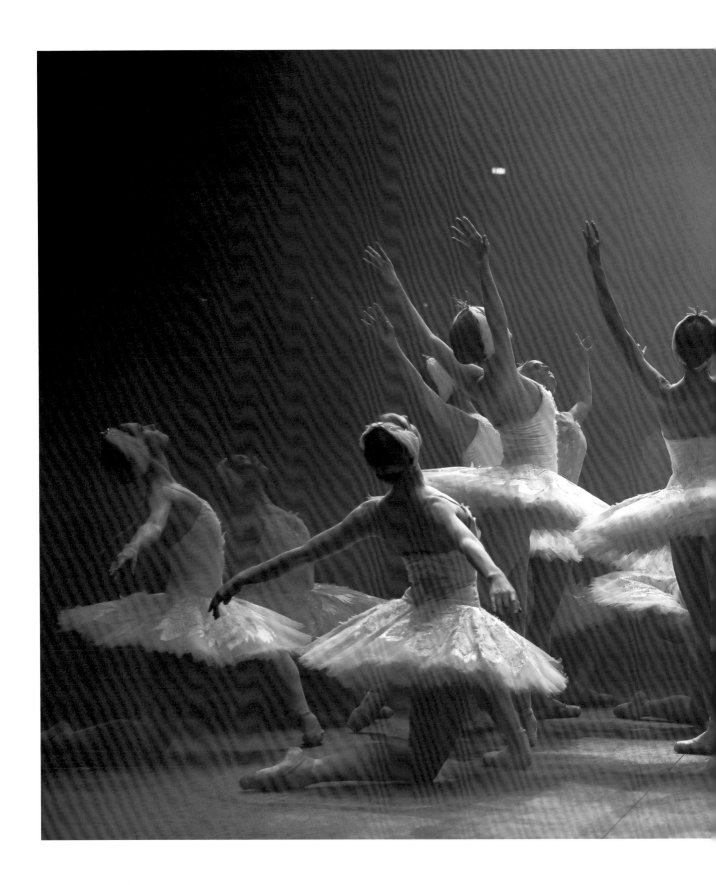

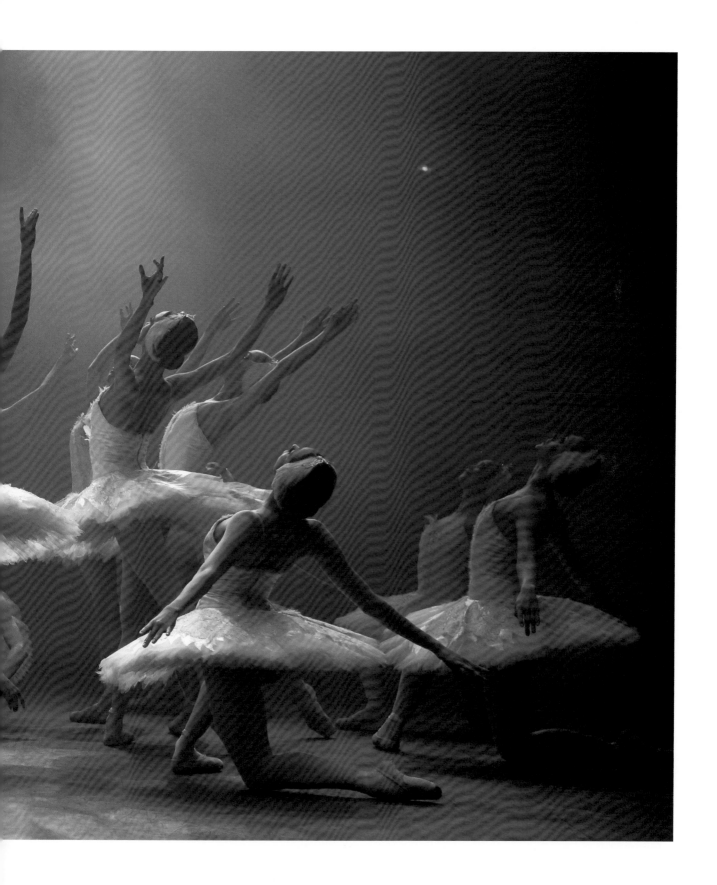

Derek Deane's *Swan Lake*, performed by English National Ballet at the Royal Albert Hall, London
11 June 2013

RIGHT
Vadim Muntagirov in Derek Deane's *Swan Lake*, performed by English National Ballet at the Royal Albert Hall, London
11 June 2013

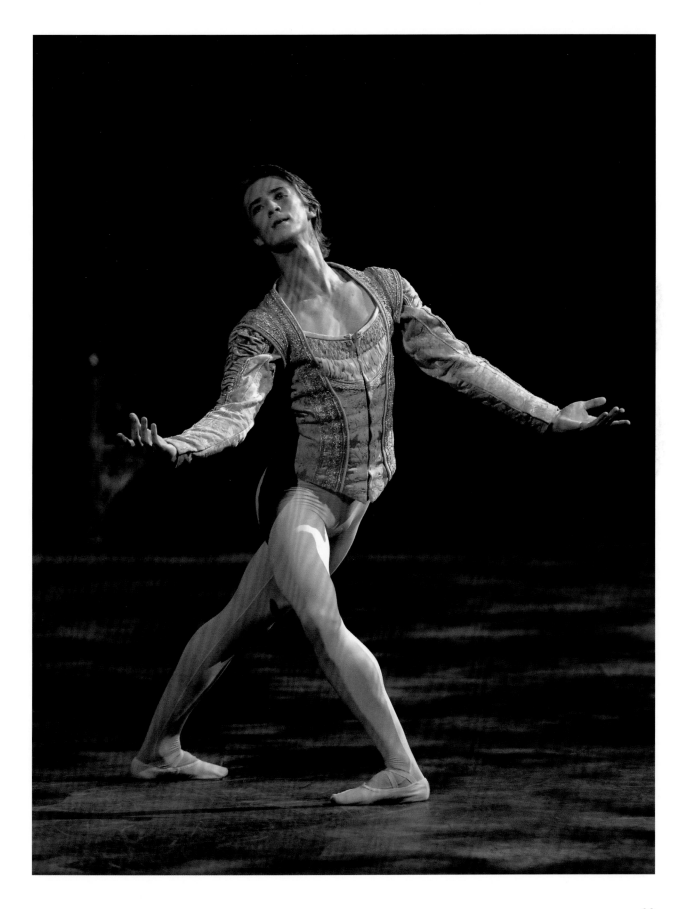

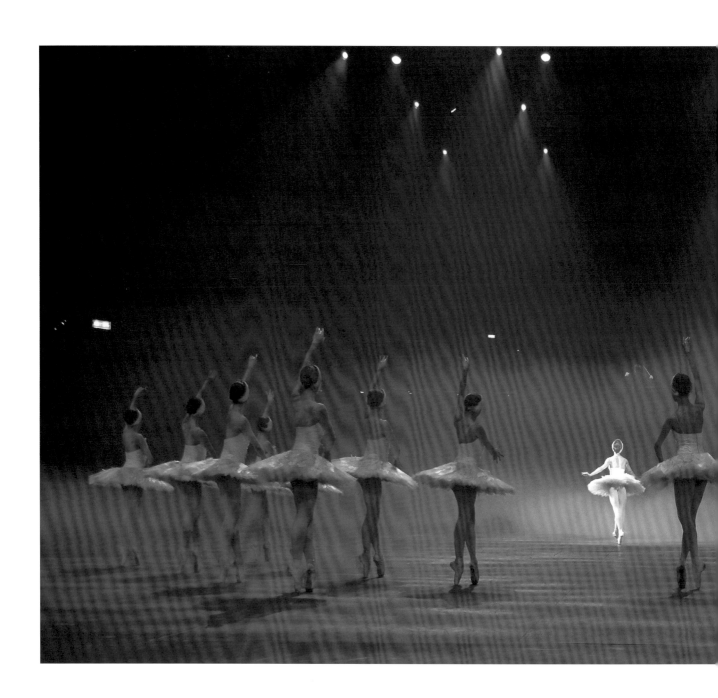

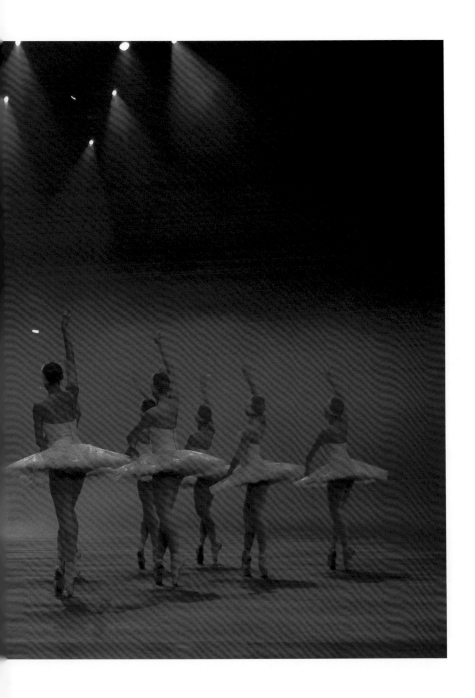

LEFT
Derek Deane's *Swan Lake*, performed by
English National Ballet at the Royal Albert
Hall, London
11 June 2013

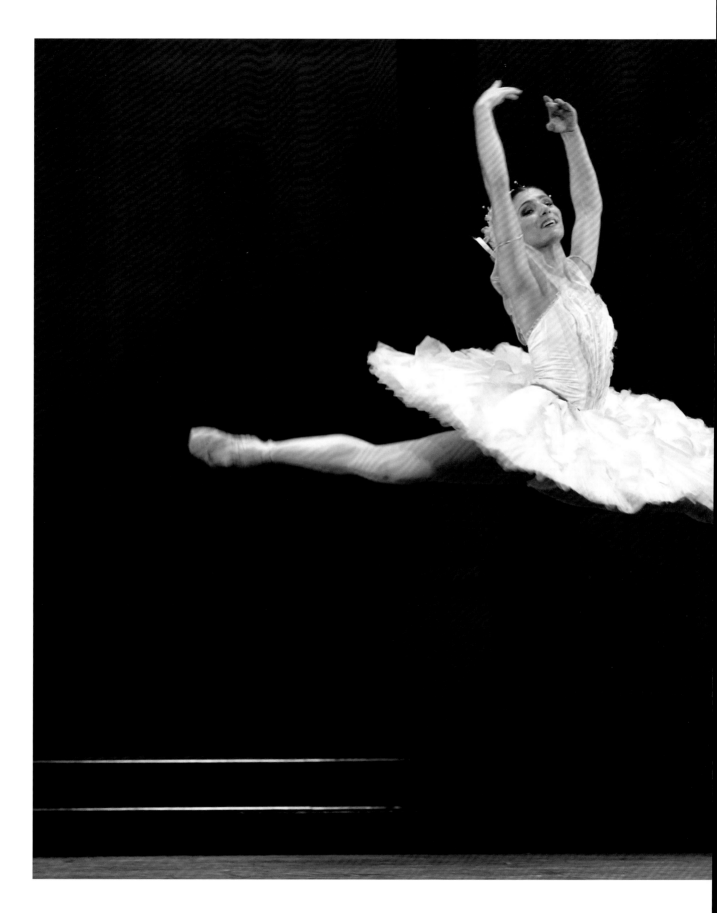

LEFT
Alina Cojocaru in Anna-Marie Holmes's
Le Corsaire, performed by English National
Ballet at Milton Keynes Theatre
16 October 2013

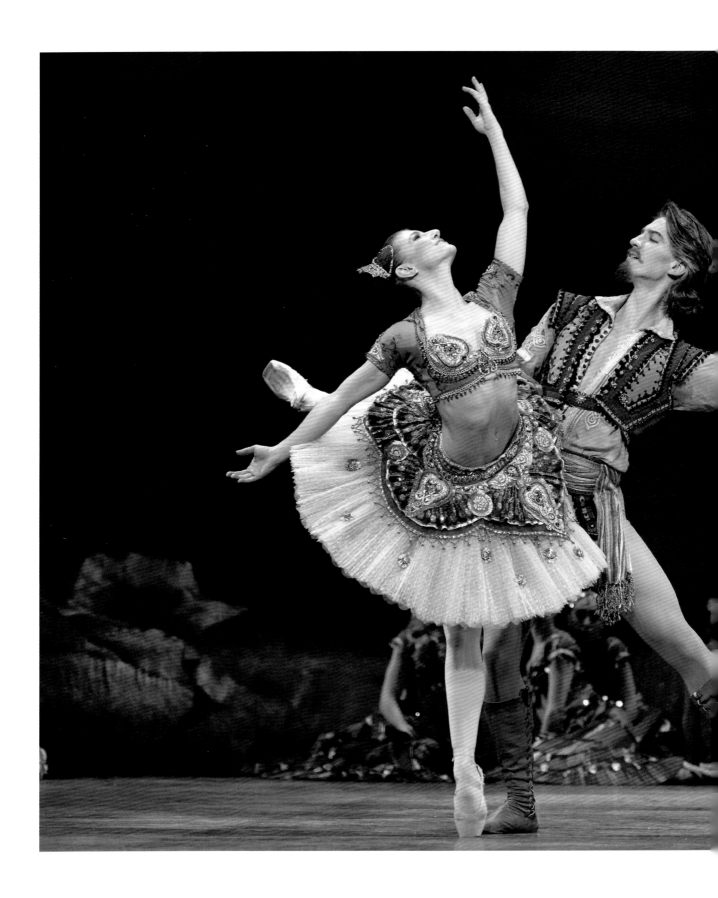

LEFT
Alina Cojocaru and Vadim Muntagirov
in Anna-Marie Holmes's *Le Corsaire*,
performed by English National Ballet at
Milton Keynes Theatre
16 October 2013

FOLLOWING PAGES
Erina Takahashi in Anna-Marie Holmes's
Le Corsaire, performed by English National
Ballet at Milton Keynes Theatre
16 October 2013

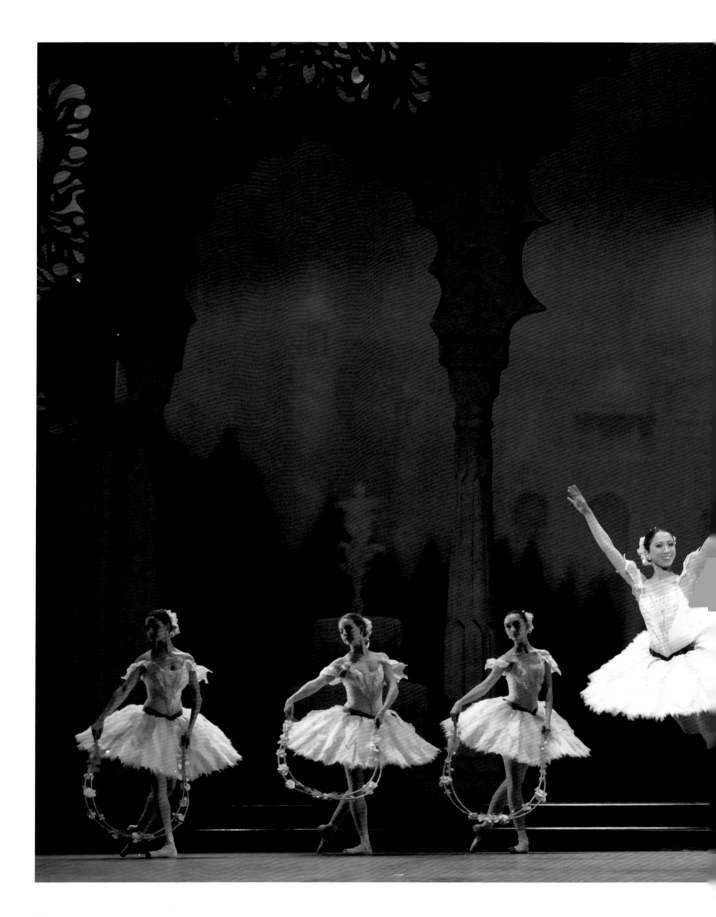

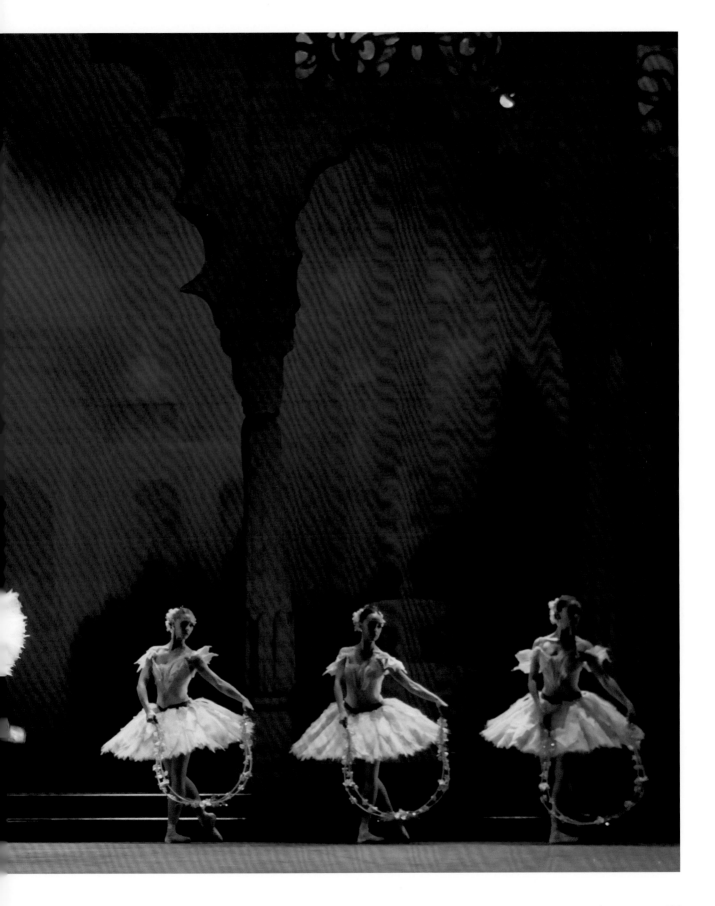

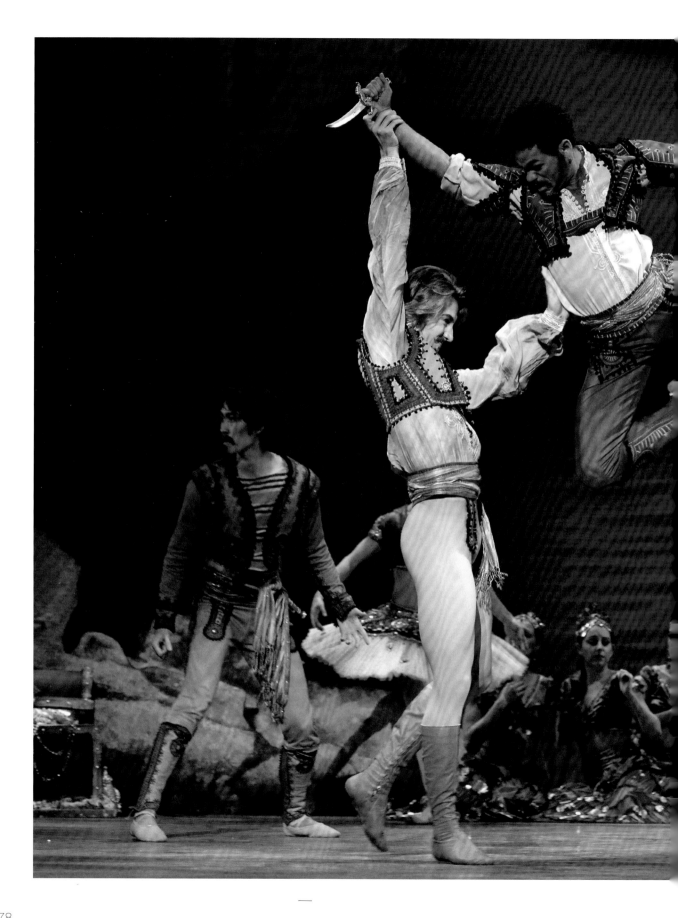

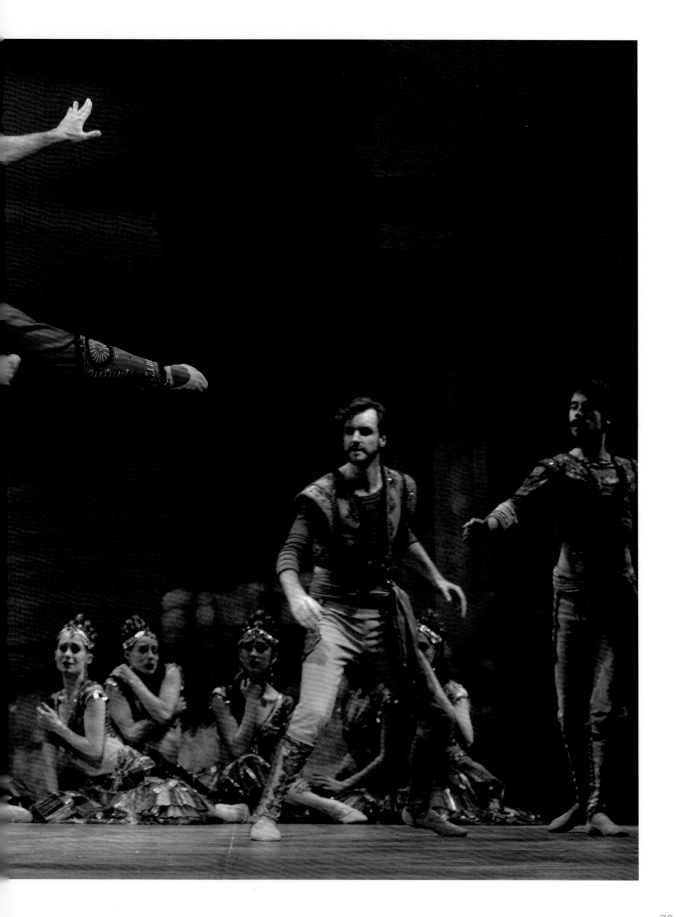

'Great dancers are not great because of their technique, they are great because of their passion.'

—MARTHA GRAHAM

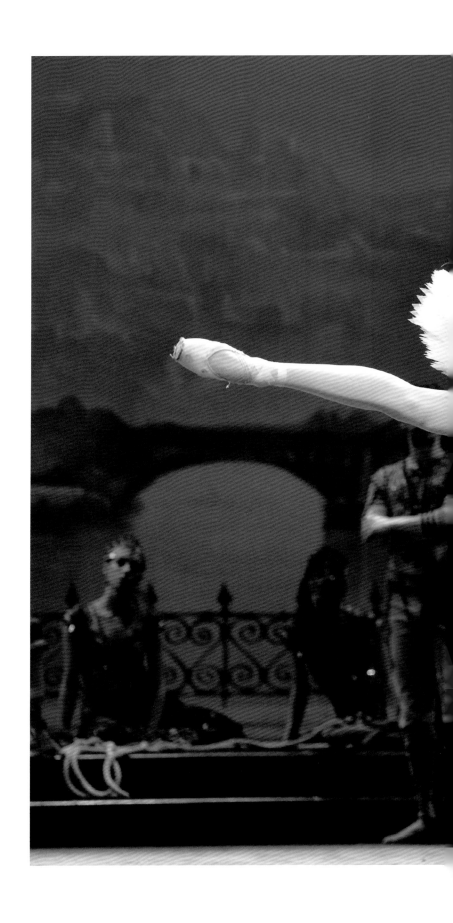

RIGHT
Ksenia Ovsyanick in Anna-Marie Holmes's
Le Corsaire, performed by English National
Ballet at the London Coliseum
8 January 2014

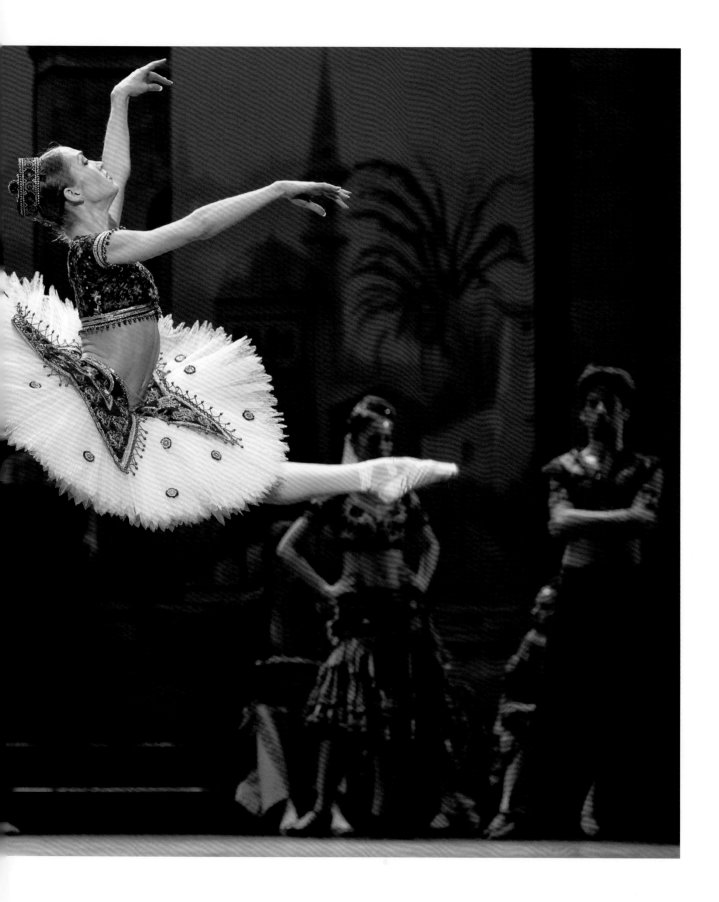

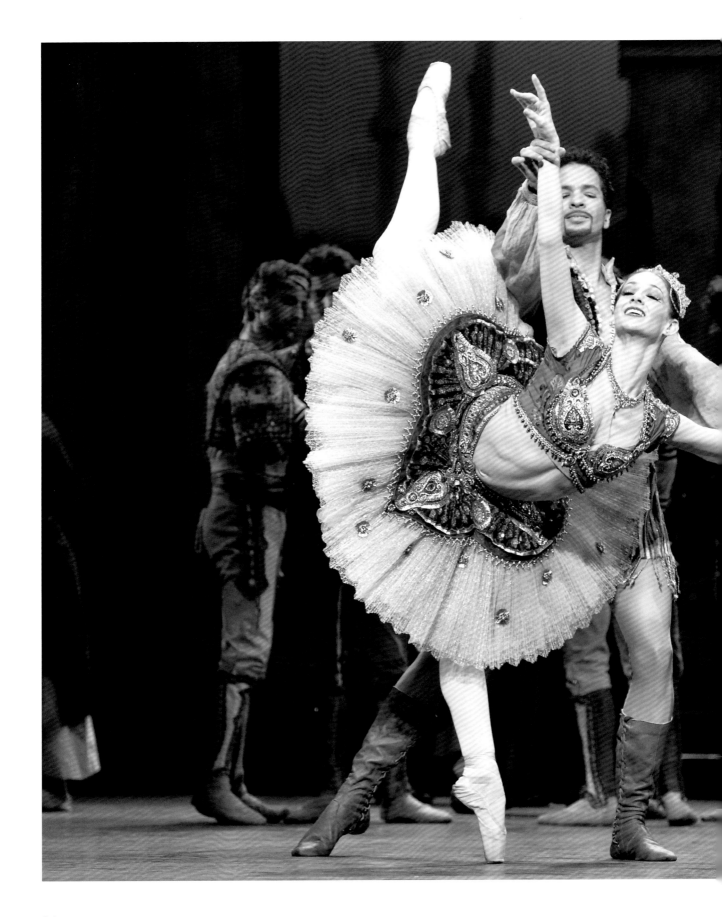

LEFT
Laurretta Summerscales and Arionel Vargas in Anna-Marie Holmes's *Le Corsaire*, performed by English National Ballet at the London Coliseum
8 January 2014

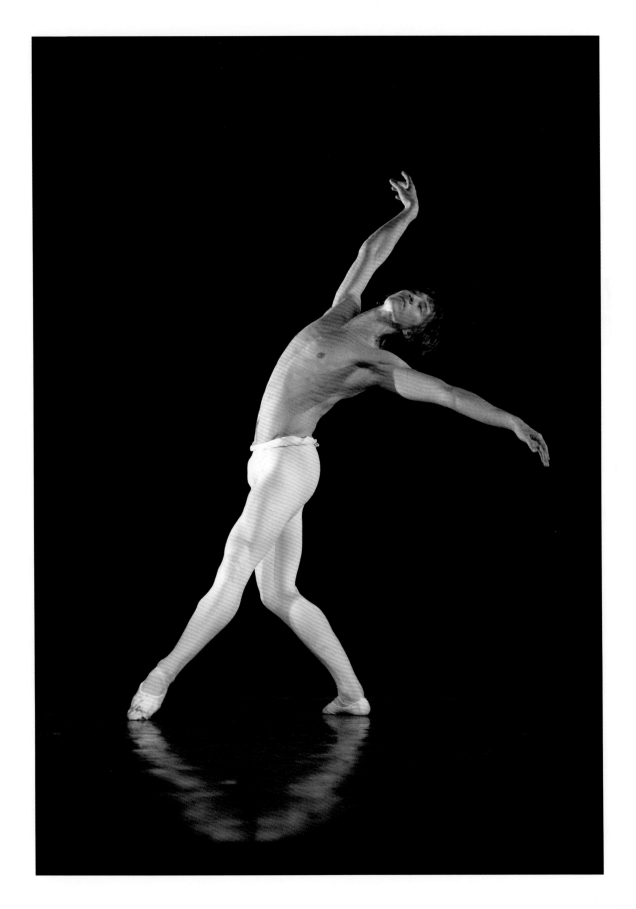

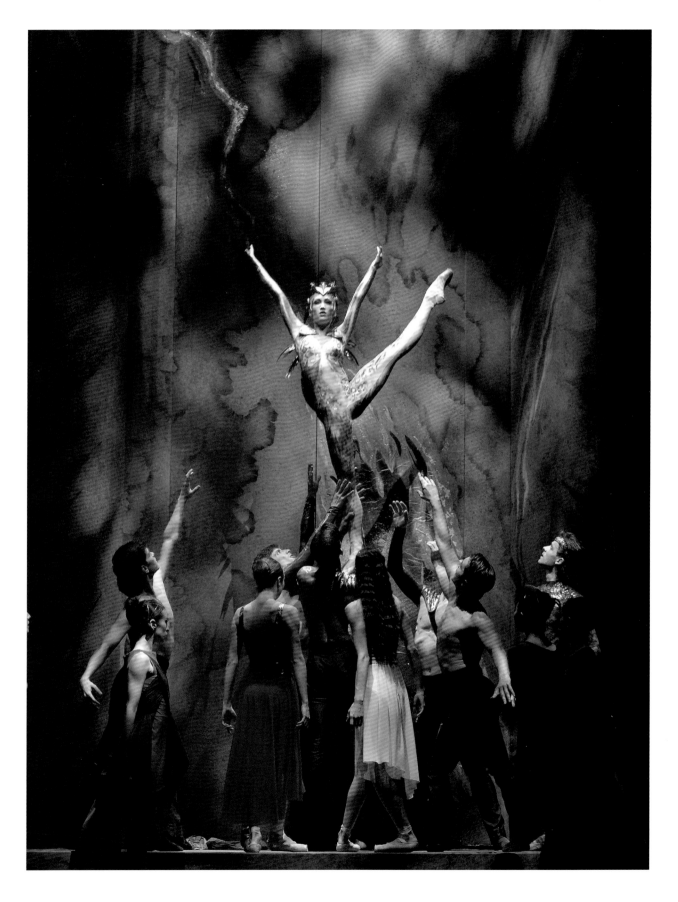

LEFT
Ksenia Ovsyanick in George Williamson's
Firebird, from Lest We Forget, performed
by English National Ballet at the Barbican
Theatre, London
1 April 2014

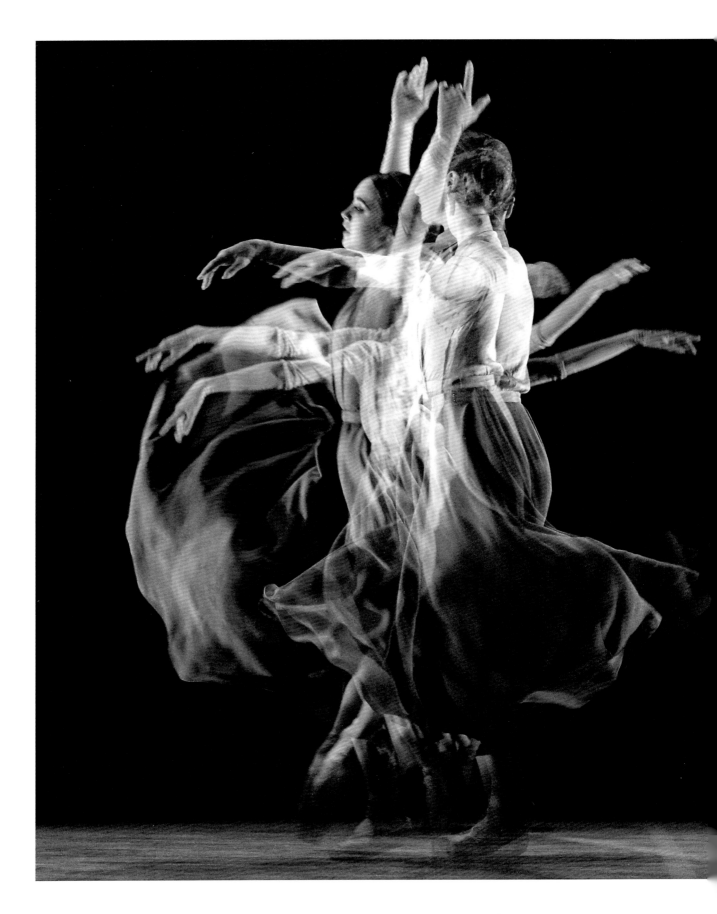

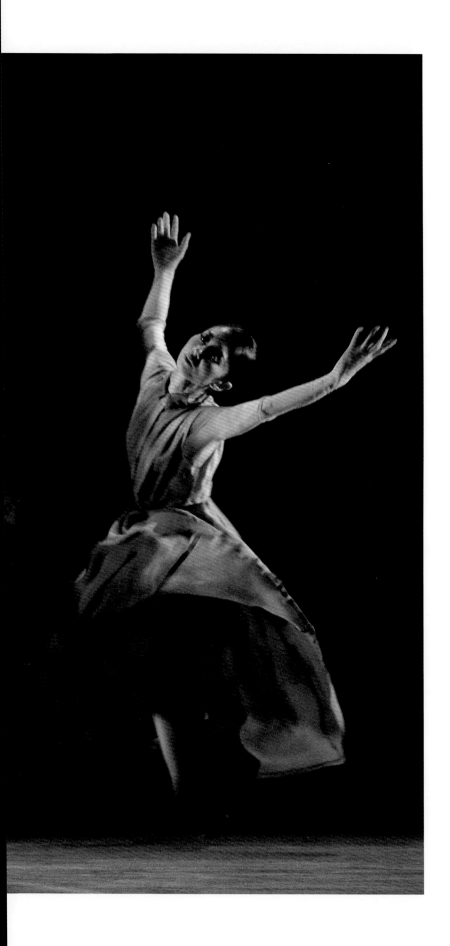

LEFT
Liam Scarlett's *No Man's Land*, from Lest We
Forget, performed by English National Ballet
at the Barbican Theatre, London
1 April 2014

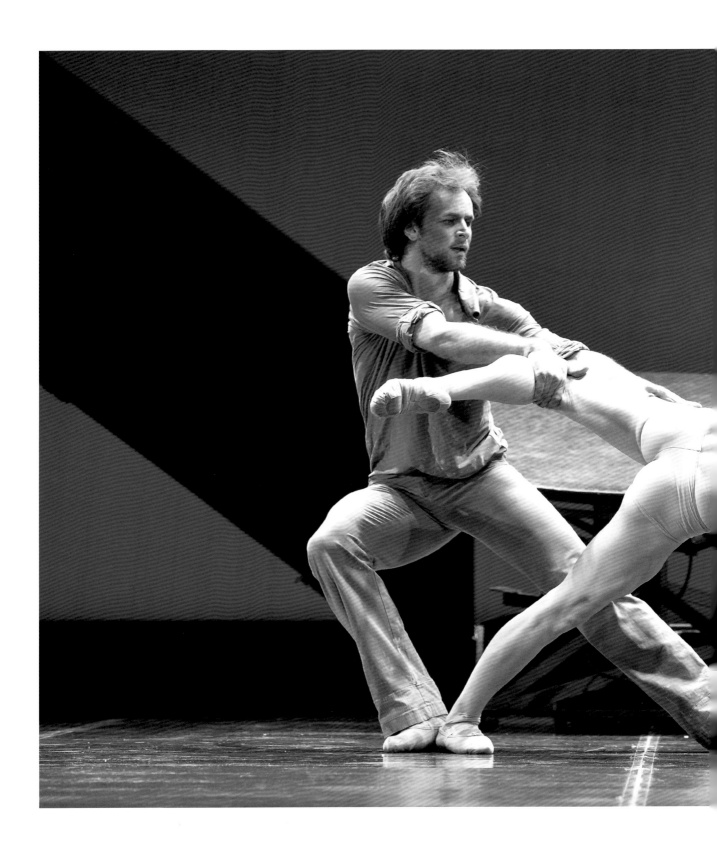

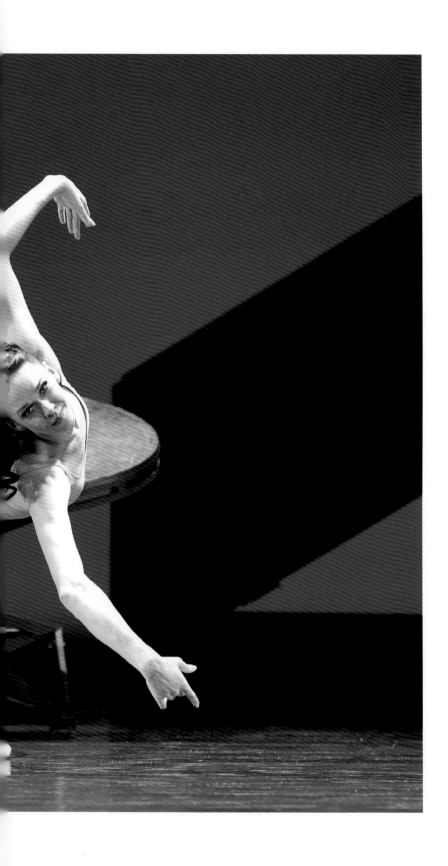

LEFT
Oleg Gabyshev and Lyubov Andreyeva
in Boris Eifman's *Rodin, Her Eternal Idol*,
performed by Eifman Ballet at the
London Coliseum
15 April 2014

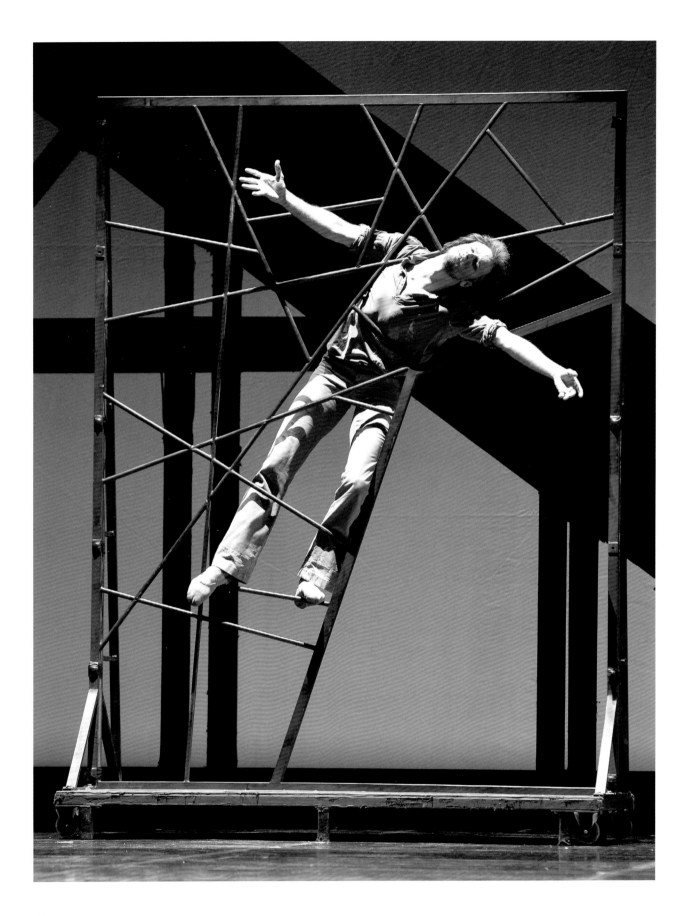

Oleg Gabyshev in Boris Eifman's *Rodin,*
Her Eternal Idol, performed by Eifman Ballet
at the London Coliseum
15 April 2014

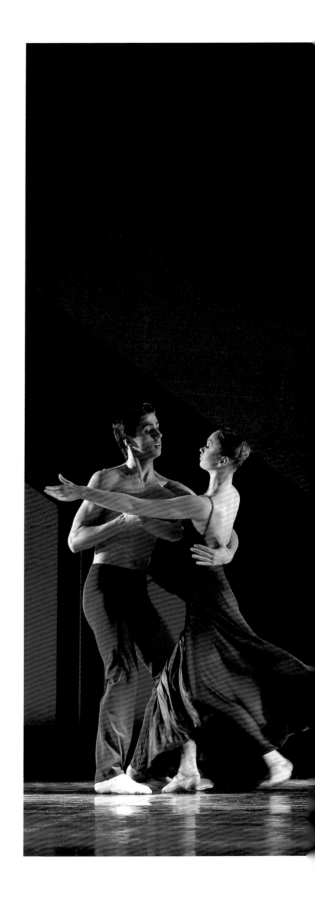

Oleg Gabyshev and Lyubov Andreyeva
in Boris Eifman's *Rodin, Her Eternal Idol*,
performed by Eifman Ballet at the
London Coliseum
15 April 2014

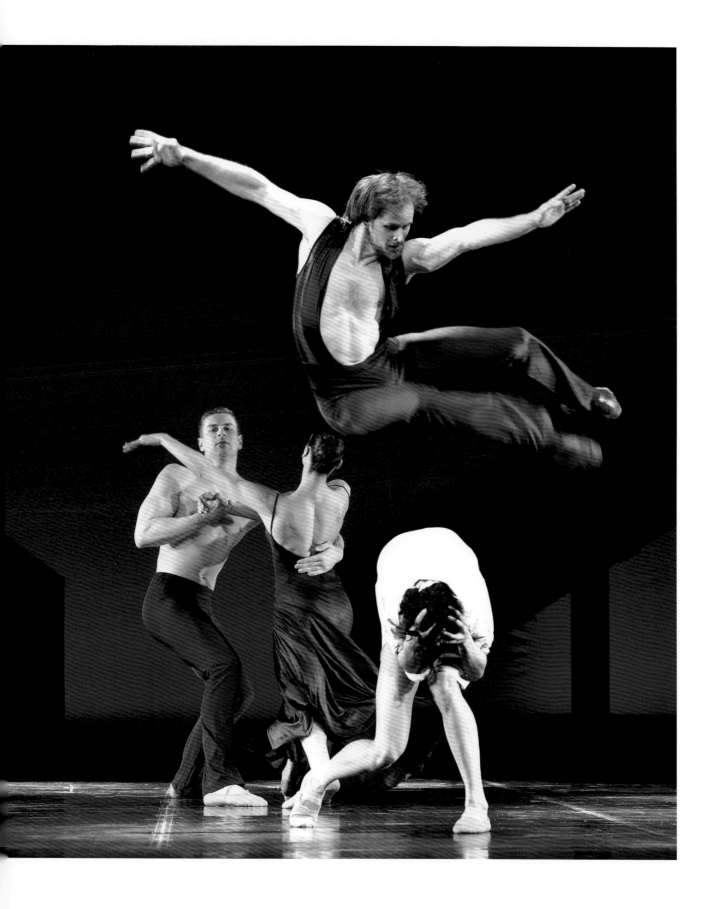

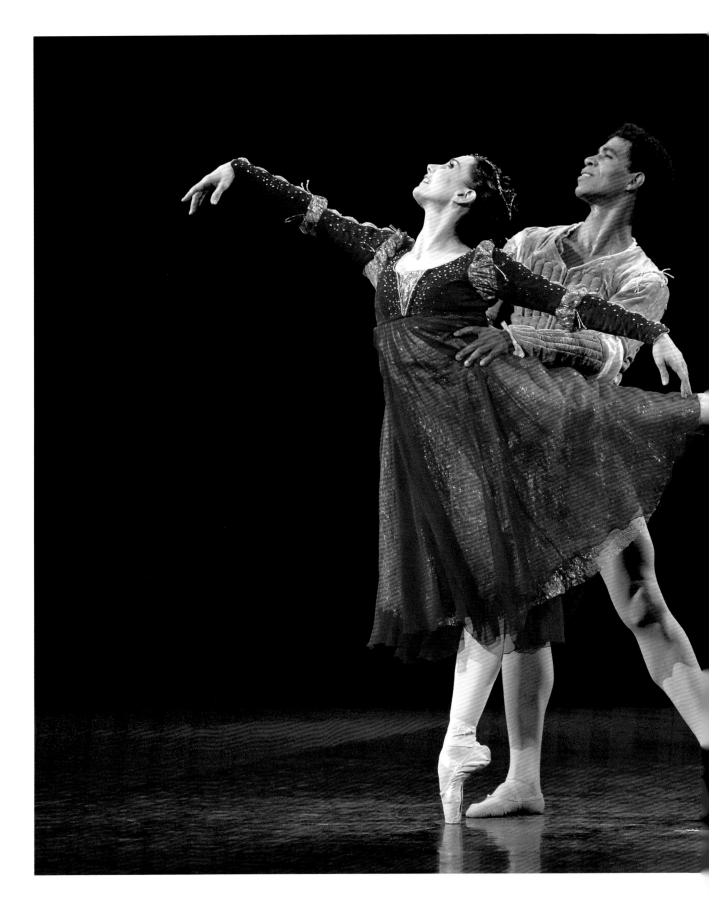

LEFT
Tamara Rojo and Carlos Acosta
in Derek Deane's *Romeo and Juliet*,
performed by English National Ballet
at the Royal Albert Hall, London
10 June 2014

Tamara Rojo and Carlos Acosta
in Derek Deane's *Romeo and Juliet*,
performed by English National Ballet
at the Royal Albert Hall, London
10 June 2014

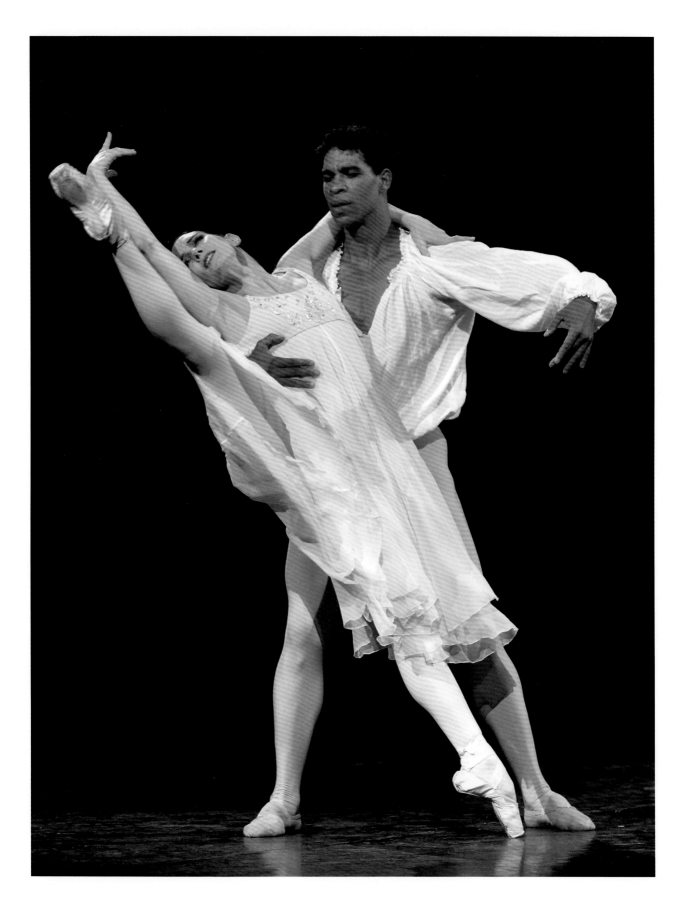

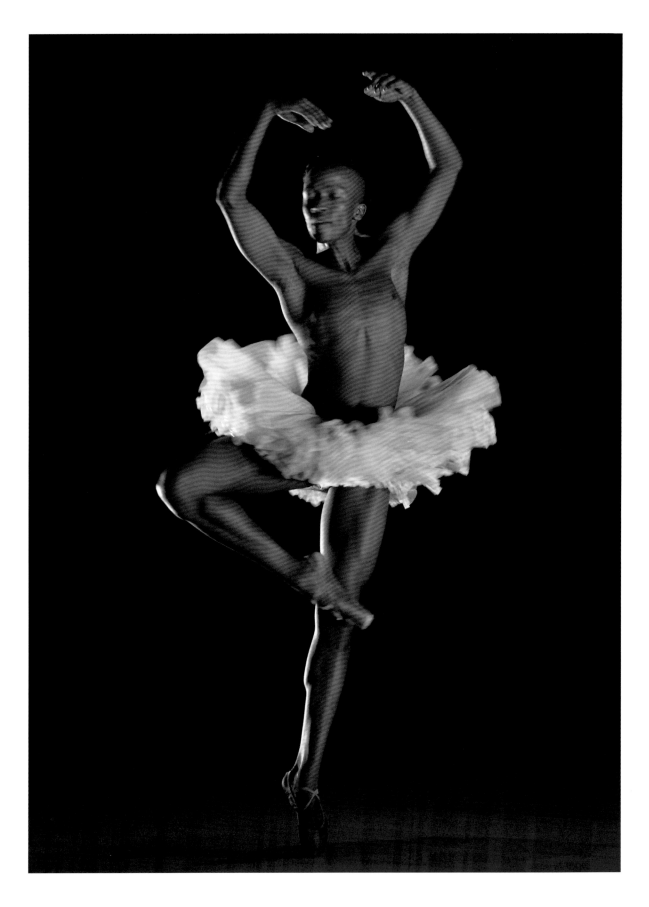

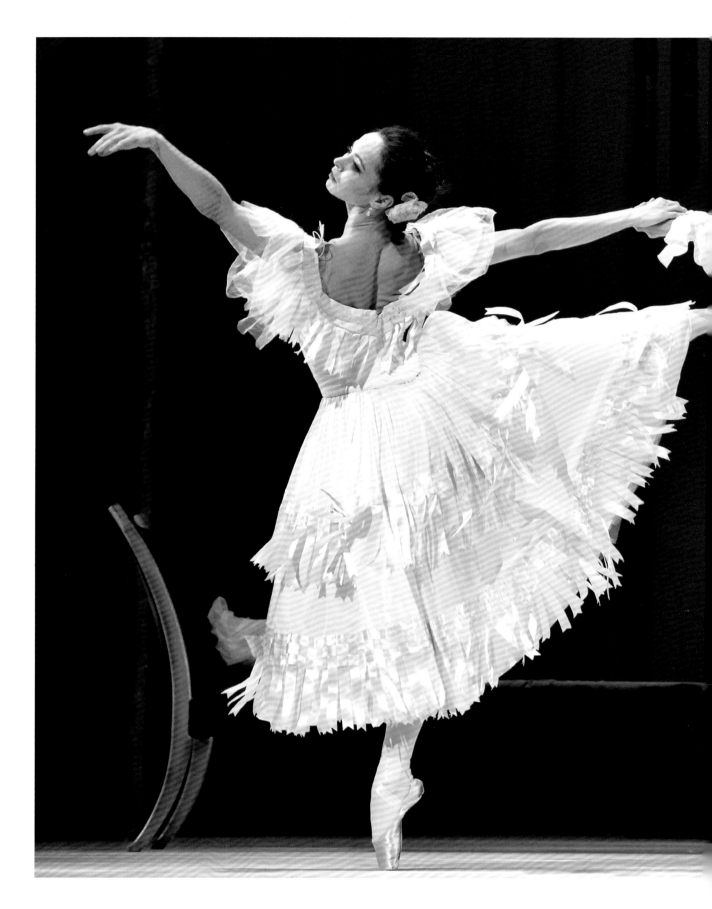

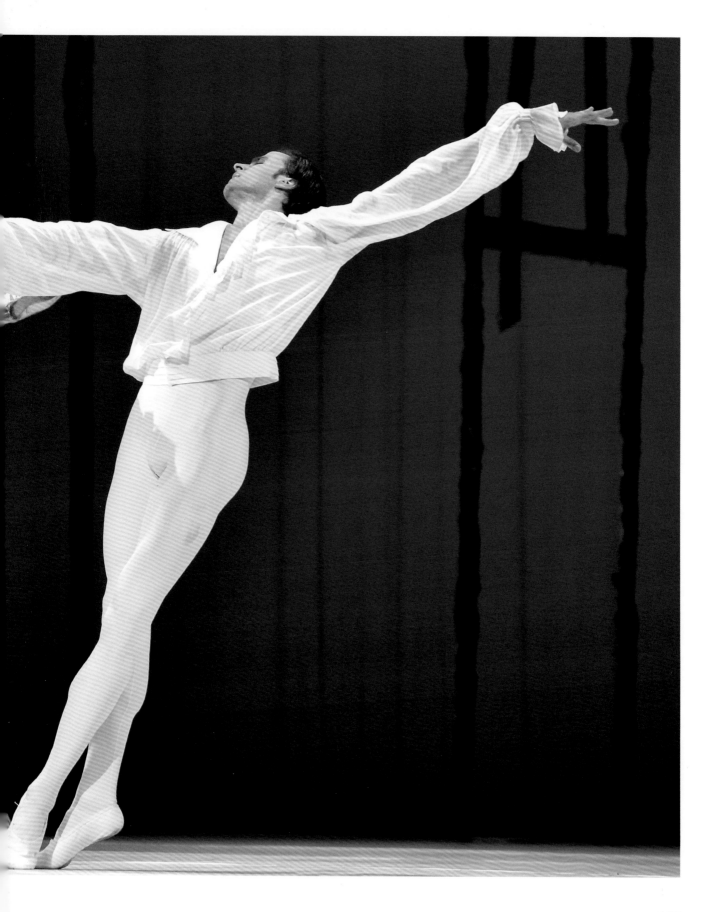

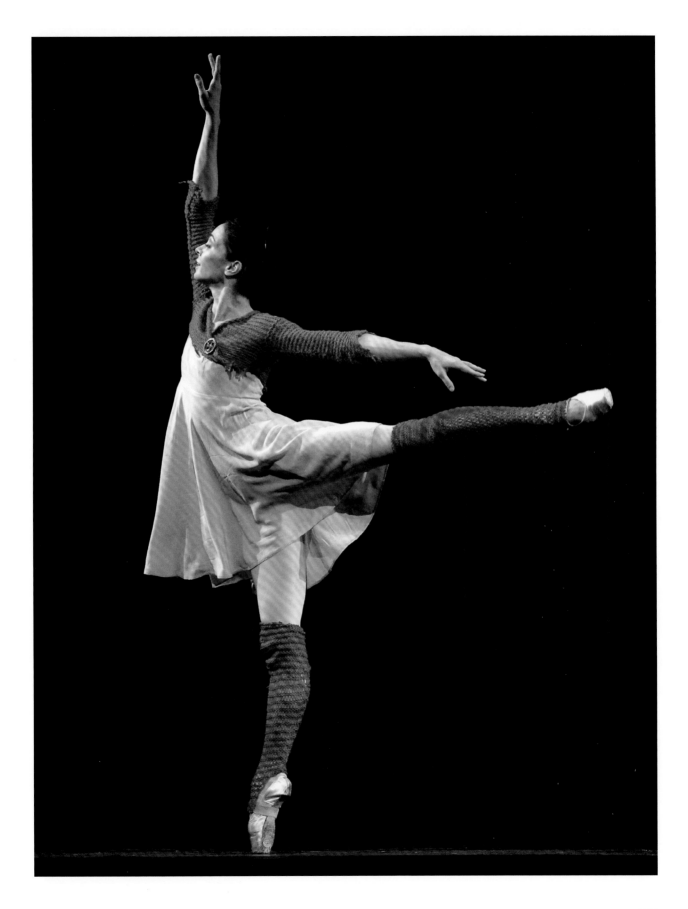

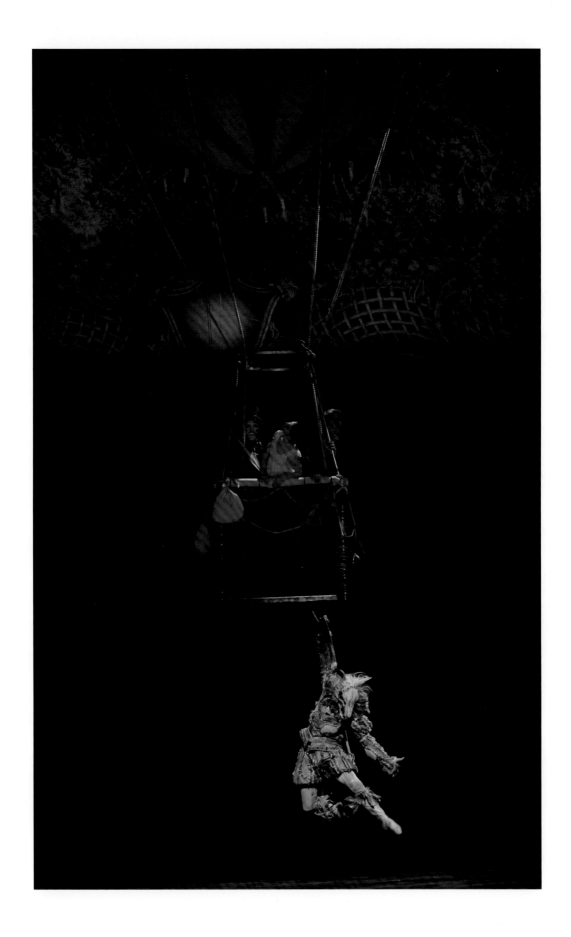

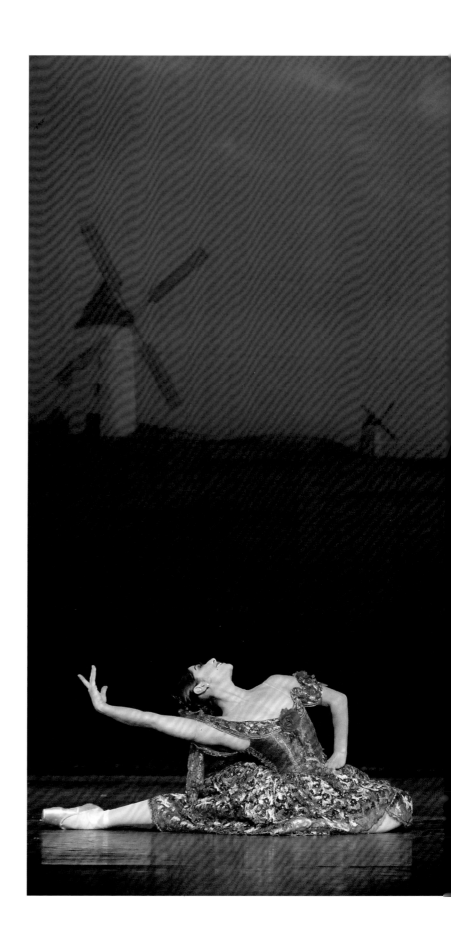

RIGHT
Crystal Costa, Anjuli Hudson and Yonah Acosta in Wayne Eagling's *Nutcracker*, performed by English National Ballet at the London Coliseum
10 December 2014

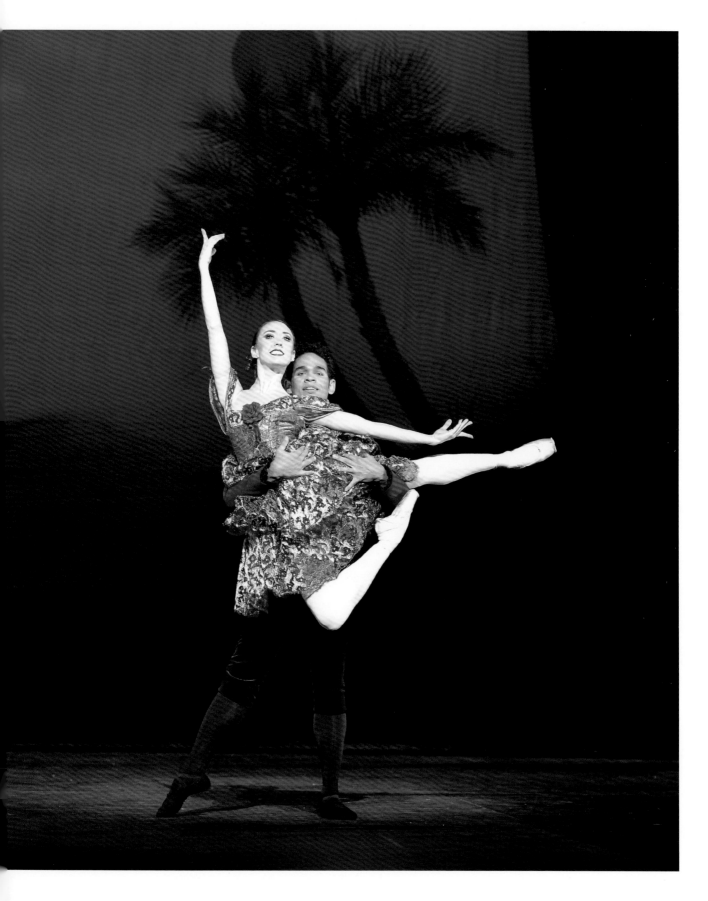

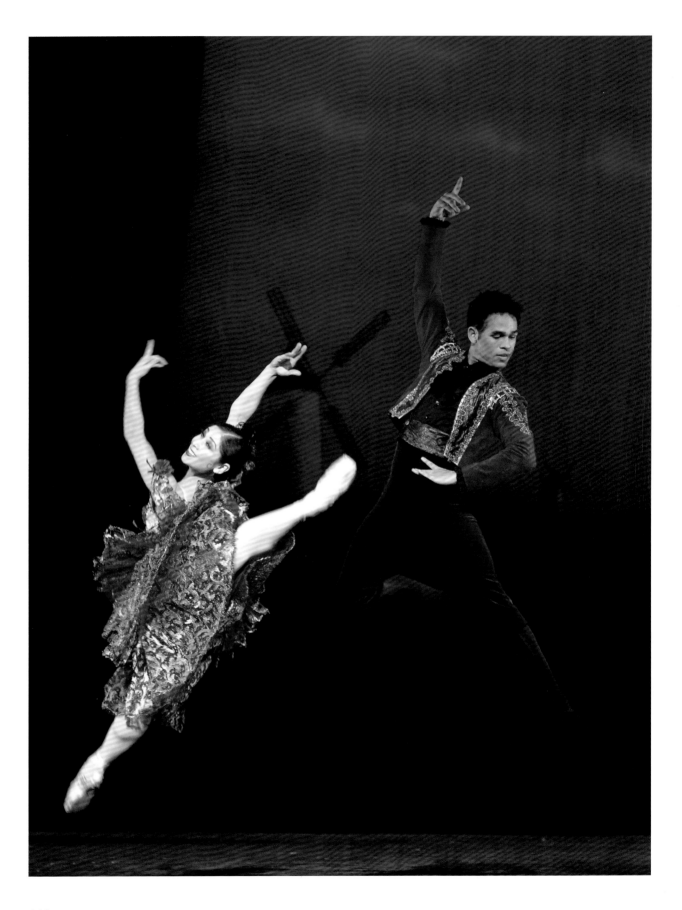

LEFT
Crystal Costa and Yonah Acosta in Wayne
Eagling's *Nutcracker*, performed by English
National Ballet at the London Coliseum
10 December 2014

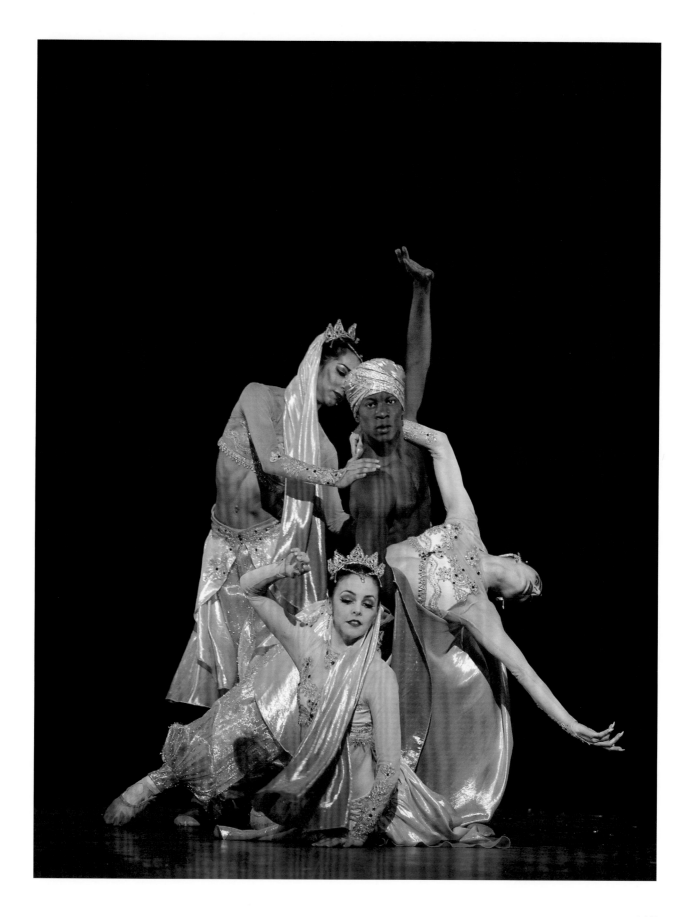

'Dance is the purest expression of every emotion, earthly and spiritual.'
—ANNA PAVLOVA

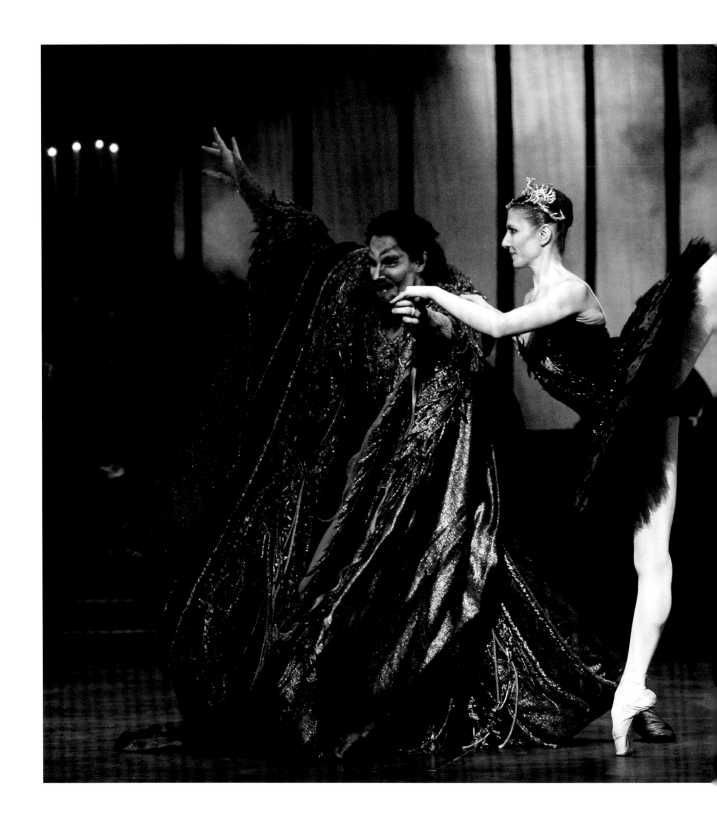

LEFT
James Streeter and Alina Cojocaru in Derek Deane's *Swan Lake*, performed by English National Ballet at the London Coliseum
6 January 2015

FOLLOWING PAGES
Derek Deane's *Swan Lake*, performed by English National Ballet at the London Coliseum
6 January 2015

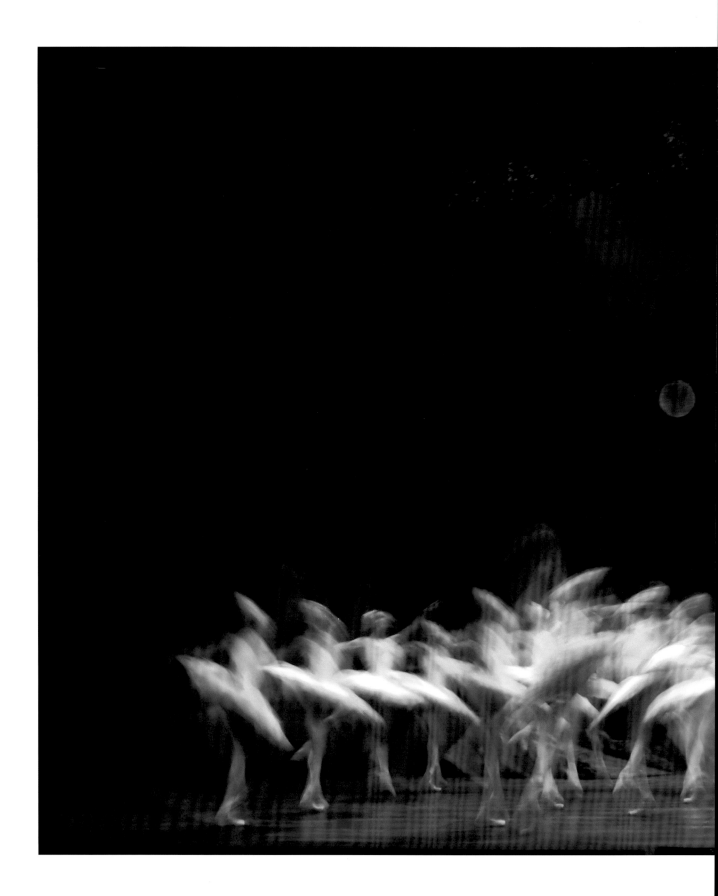

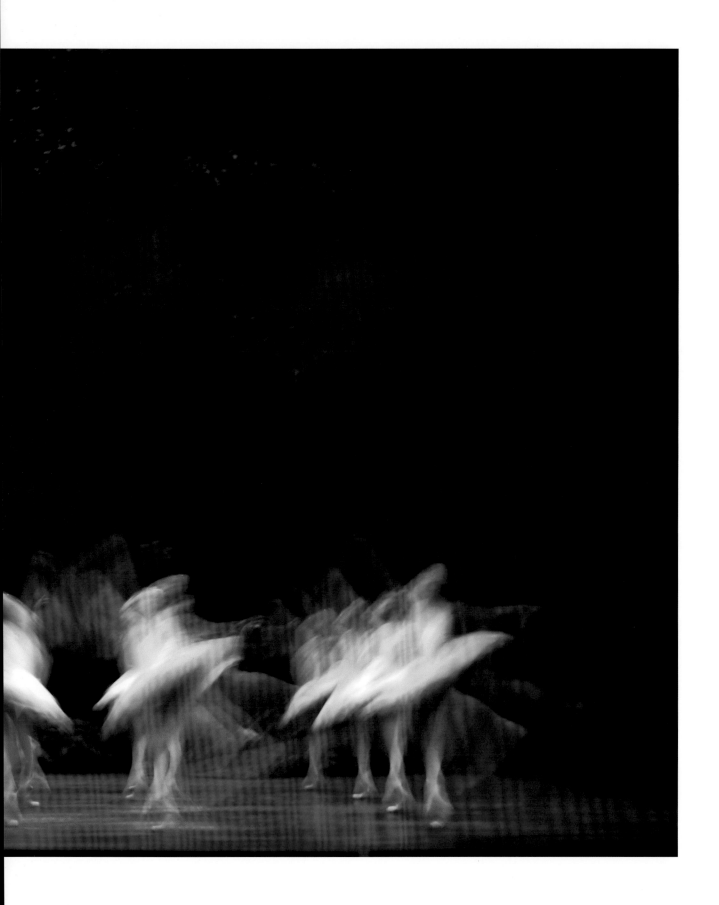

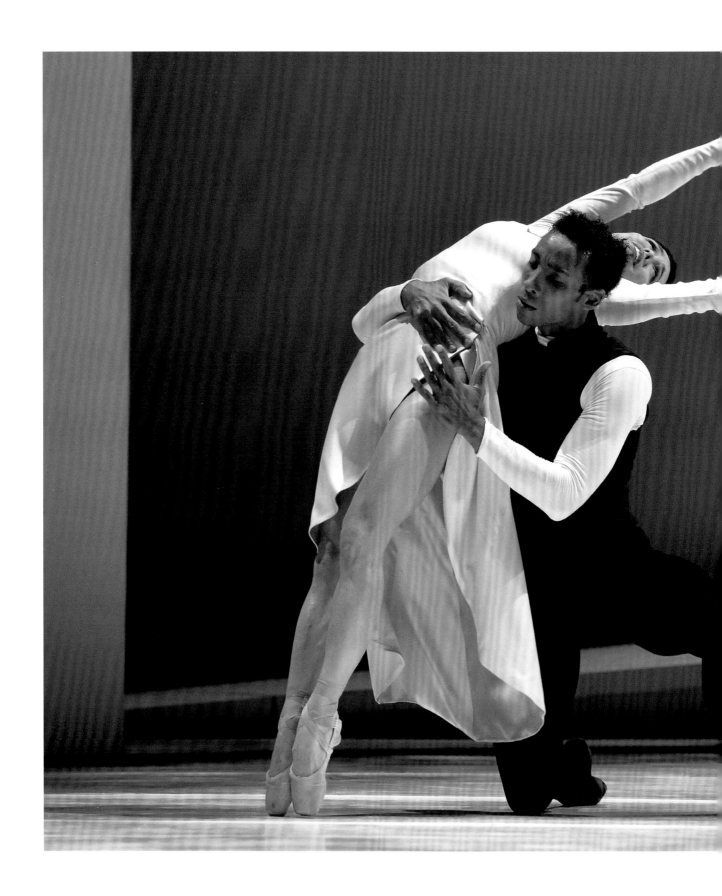

Noelani Pantastico and George Oliveira in
Jean-Christophe Maillot's *Romeo and Juliet*,
performed by Les Ballets de Monte-Carlo at
the London Coliseum
22 April 2015

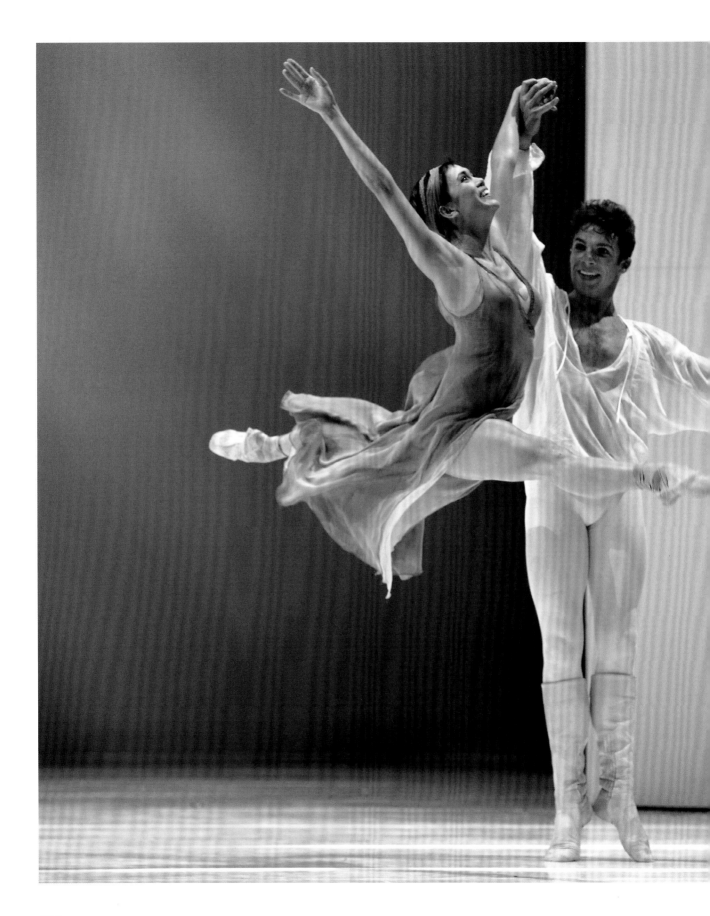

LEFT
Noelani Pantastico and Lucien Postlewaite
in Jean-Christophe Maillot's *Romeo and
Juliet*, performed by Les Ballets de Monte-
Carlo at the London Coliseum
22 April 2015

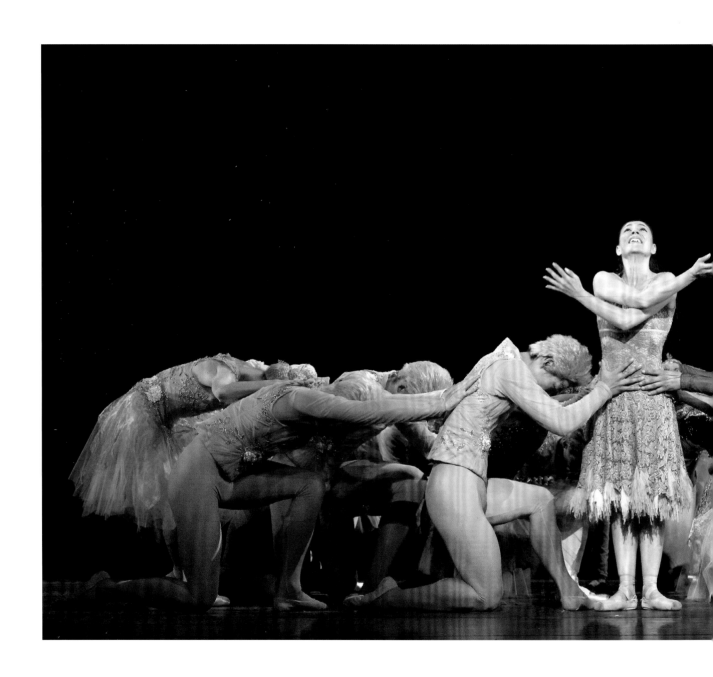

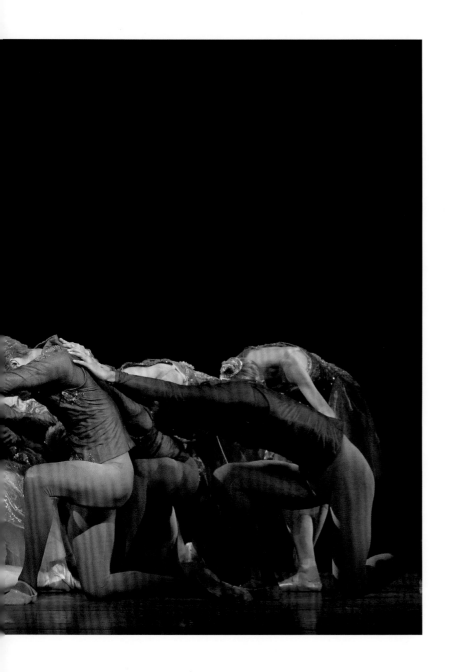

LEFT
Anna Tsygankova in Christopher
Wheeldon's *Cinderella*, performed by Dutch
National Ballet at the London Coliseum
8 July 2015

FOLLOWING PAGES
Matthew Golding and Anna Tsygankova
in Christopher Wheeldon's *Cinderella*,
performed by Dutch National Ballet at the
London Coliseum
8 July 2015

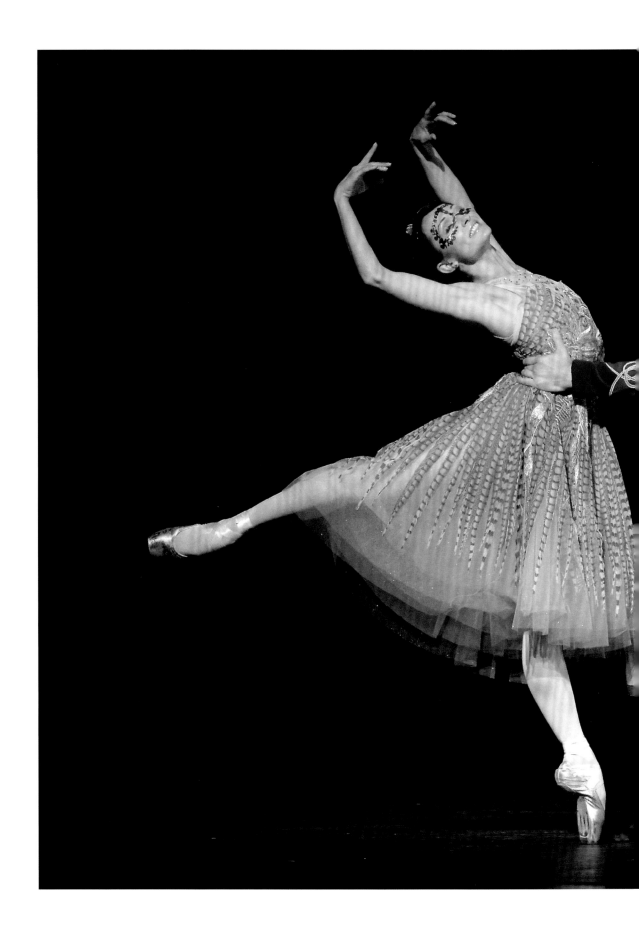

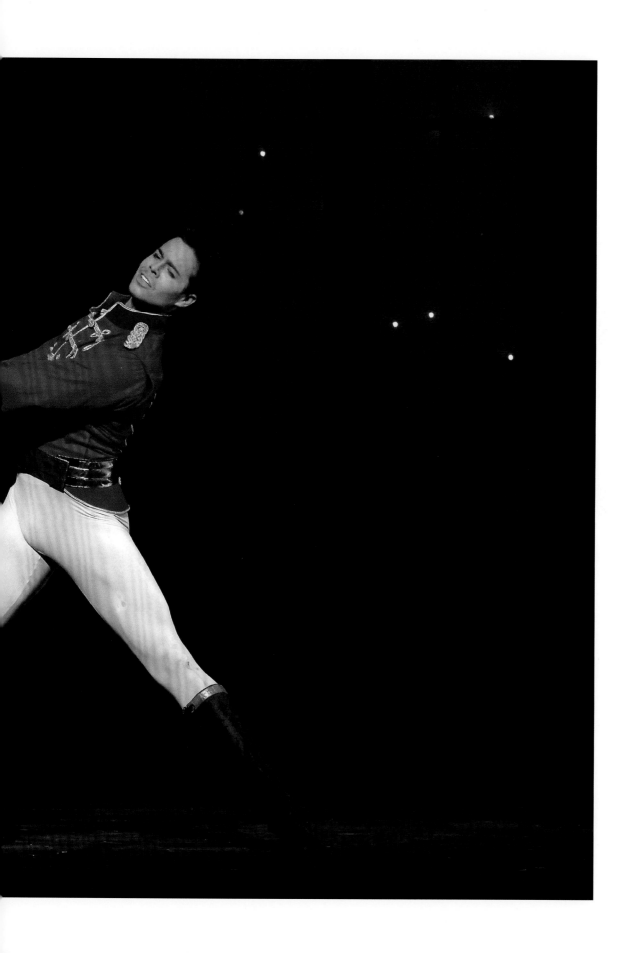

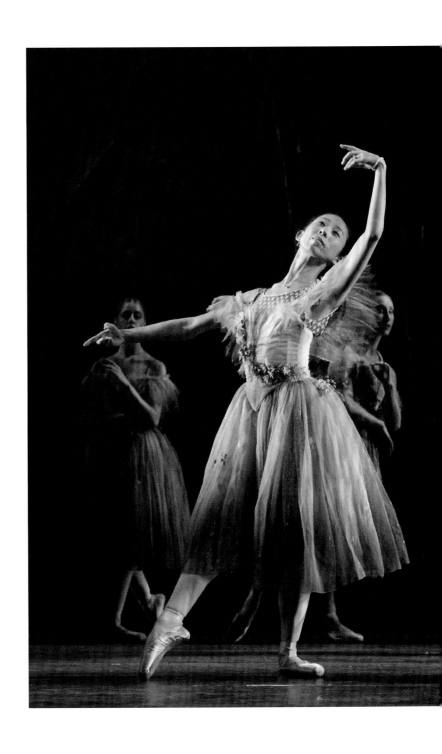

RIGHT
Lina Kim, Clare Morehen and Tara Schaufuss in Peter Schaufuss's *La Sylphide*, performed by Queensland Ballet at the London Coliseum
4 August 2015

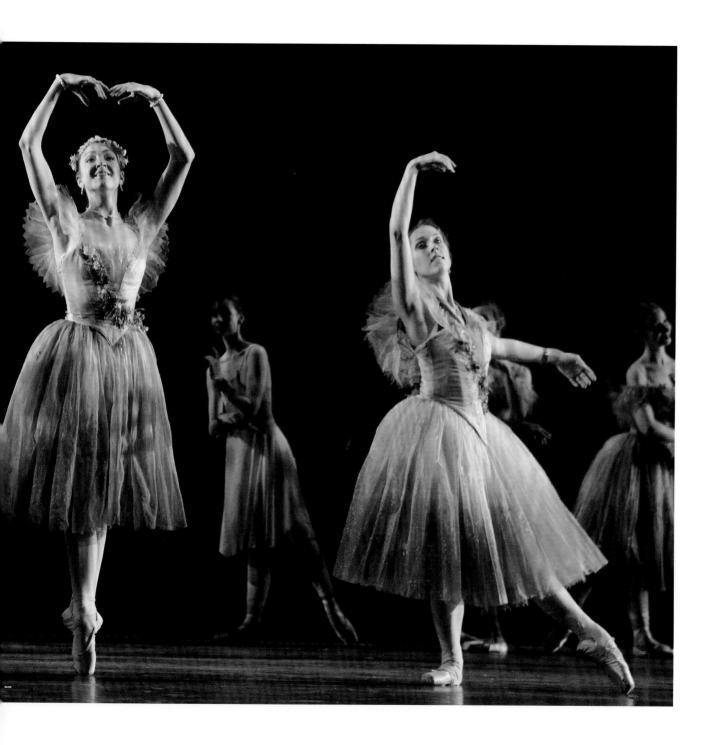

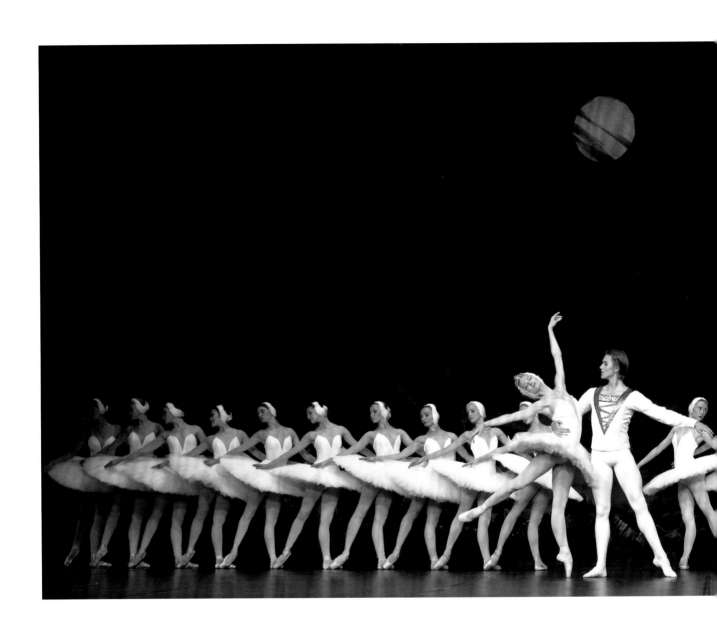

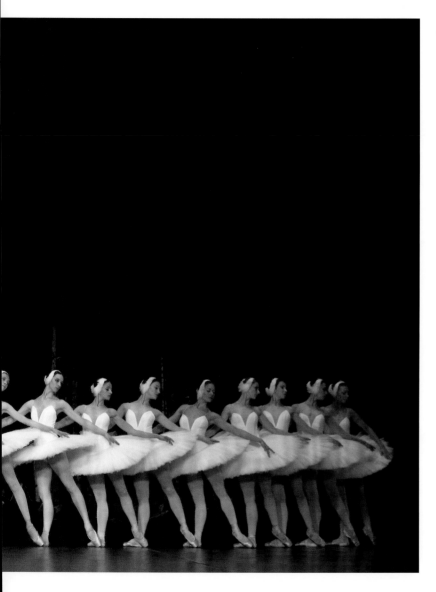

LEFT
Yuri Gumba's *Swan Lake*, performed
by St Petersburg Ballet Theatre at the
London Coliseum
13 August 2015

RIGHT AND FOLLOWING PAGES
Denis Rodkin in Yuri Gumba's *Swan Lake*,
performed by St Petersburg Ballet Theatre at
the London Coliseum
13 August 2015

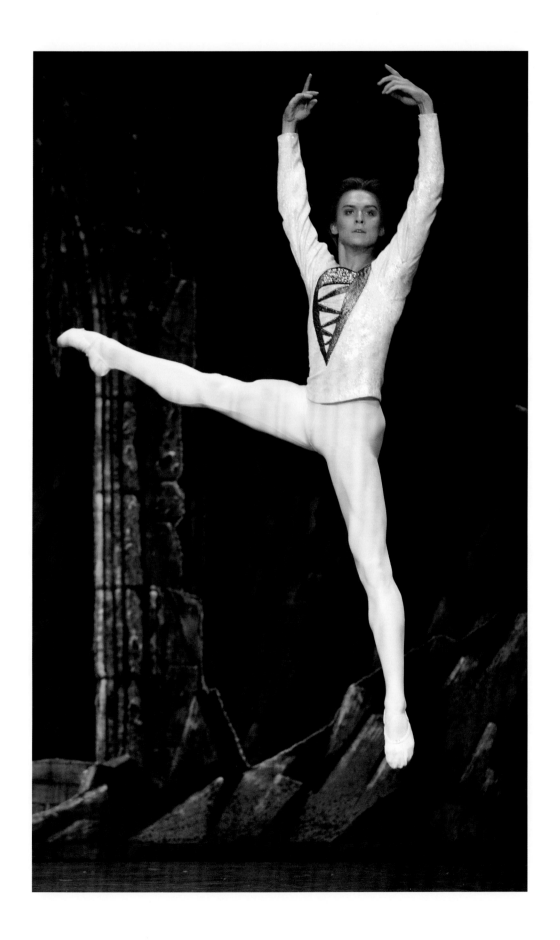

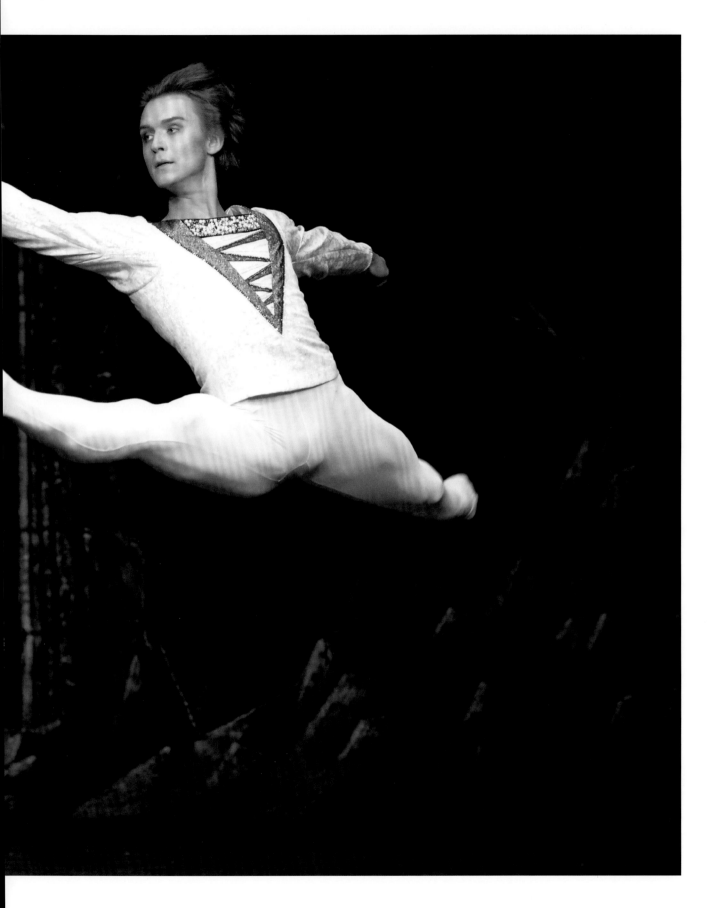

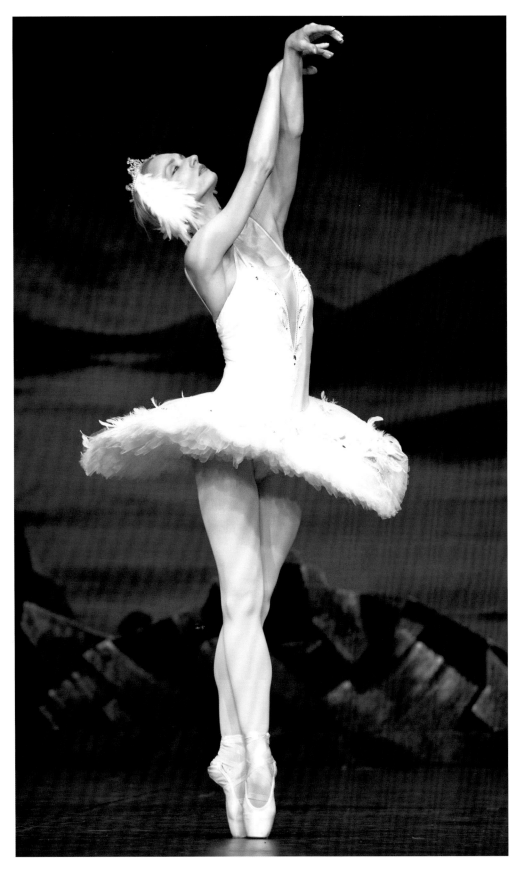

LEFT AND RIGHT
Irina Kolesnikova
in Yuri Gumba's
Swan Lake, performed
by St Petersburg
Ballet Theatre at the
London Coliseum
13 August 2015

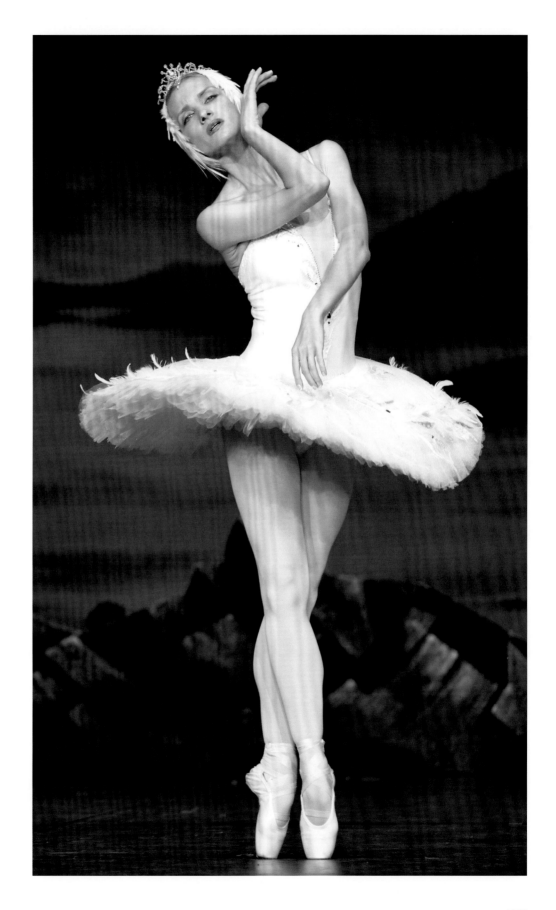

'To dance is to investigate and celebrate the feeling of being alive.'

—CRYSTAL PITE

FOLLOWING PAGES
Akram Khan's *Dust*, from Lest We Forget,
performed by English National Ballet at
Sadler's Wells, London
7 September 2015

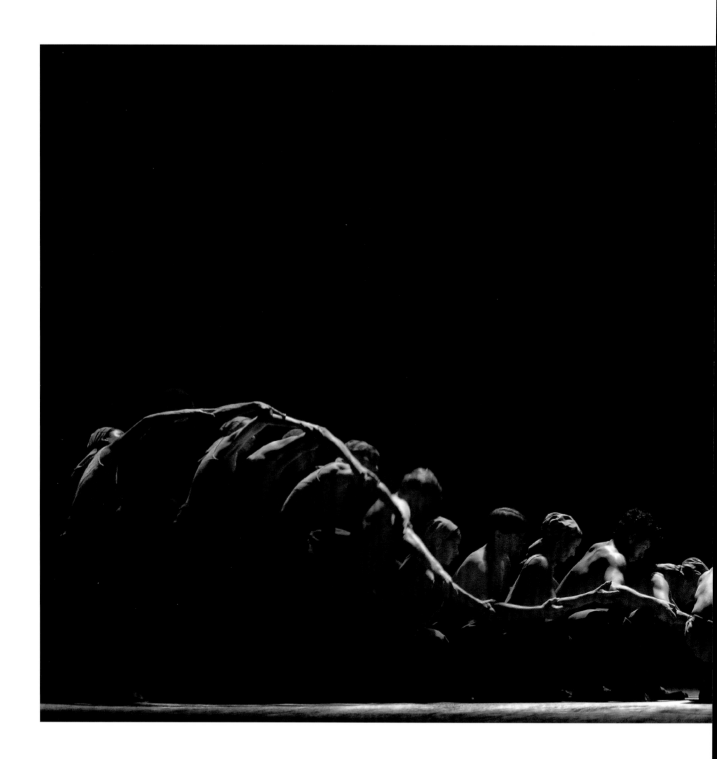

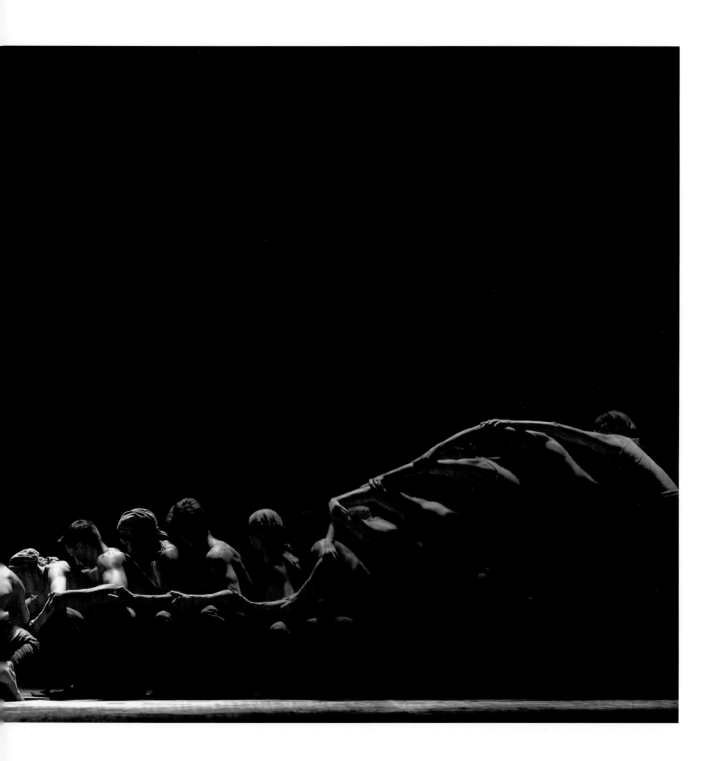

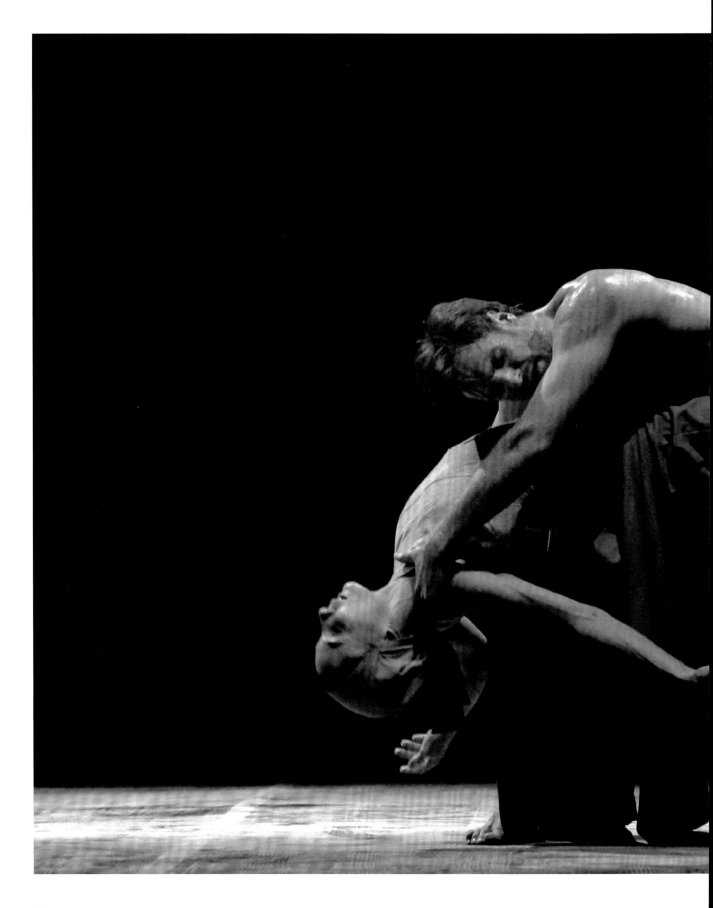

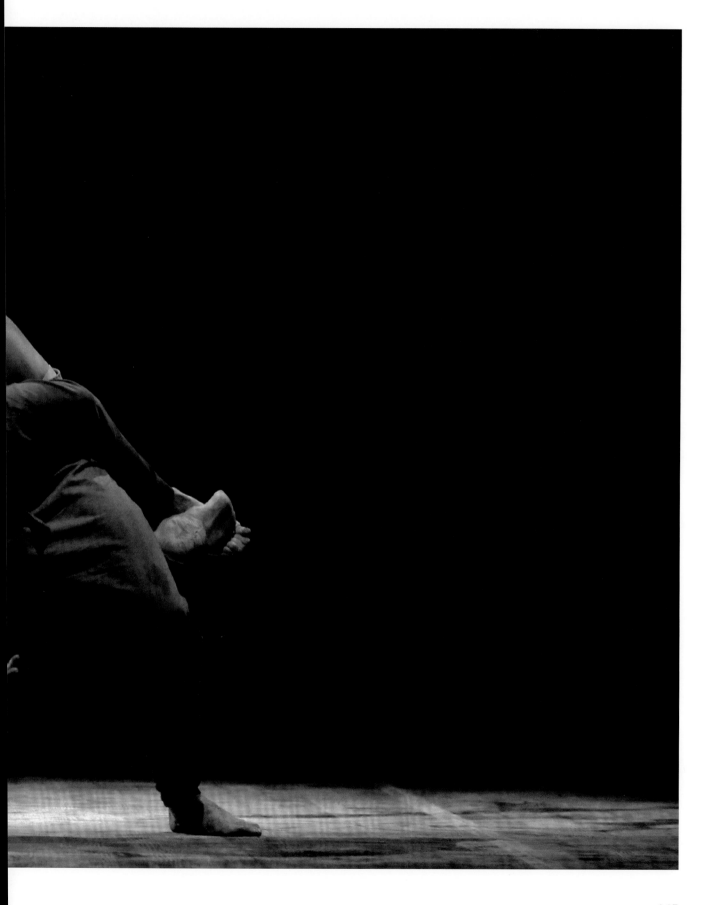

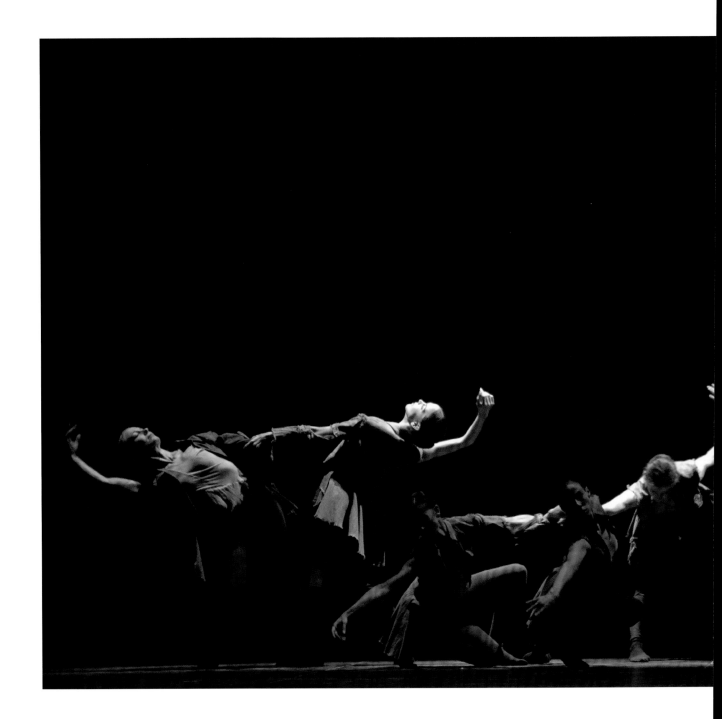

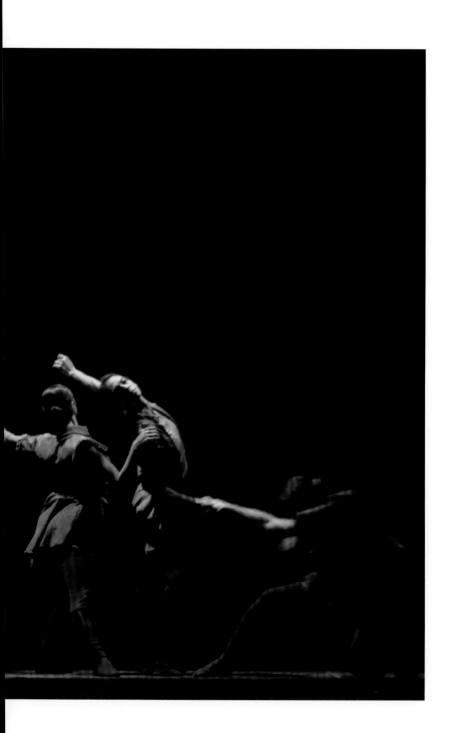

PRECEDING PAGES
Tamara Rojo and James Streeter
in Akram Khan's *Dust*, from Lest We Forget,
performed by English National Ballet at
Sadler's Wells, London
7 September 2015

LEFT
Russell Maliphant's *Second Breath*, from
Lest We Forget, performed by English
National Ballet at Sadler's Wells, London
7 September 2015

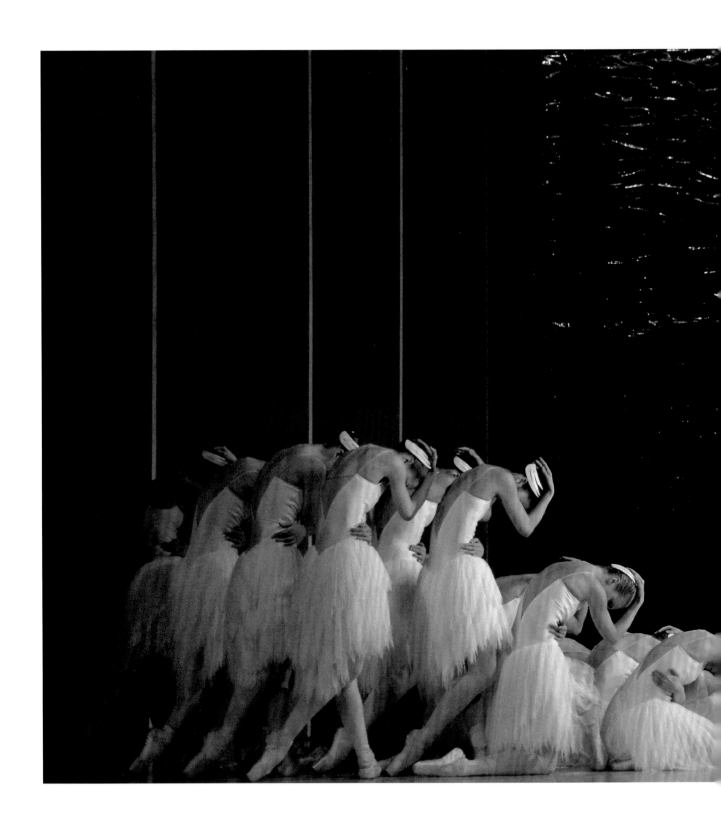

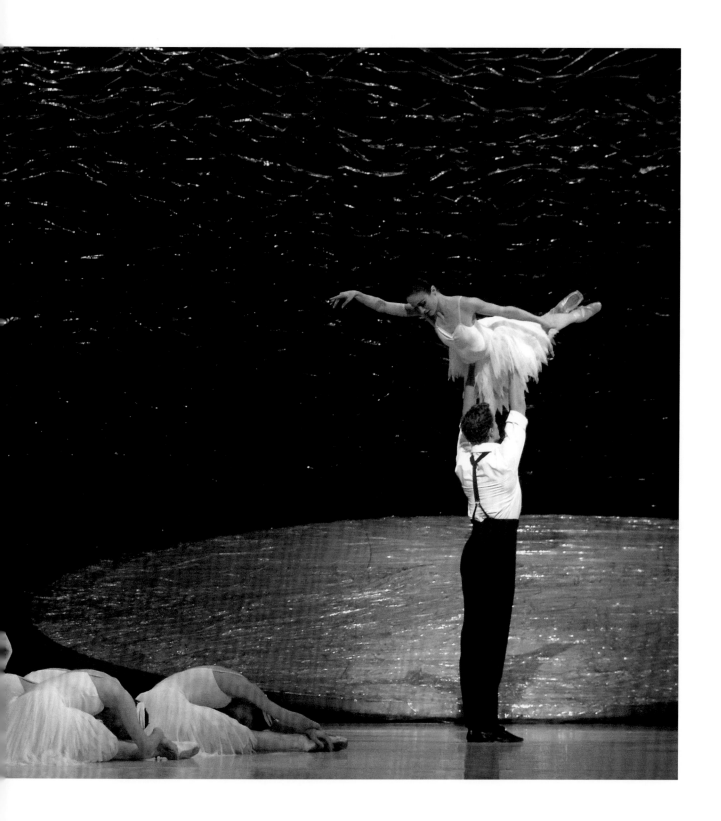

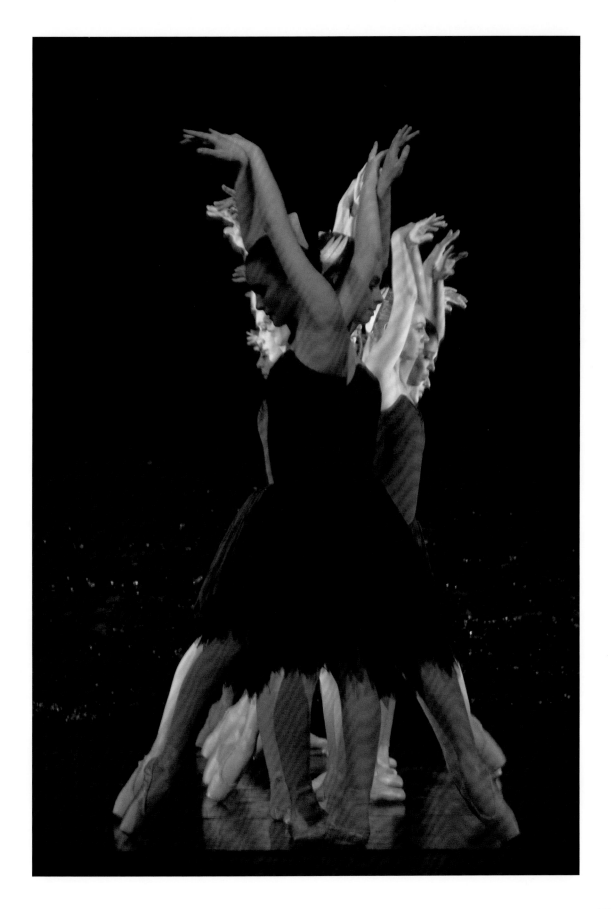

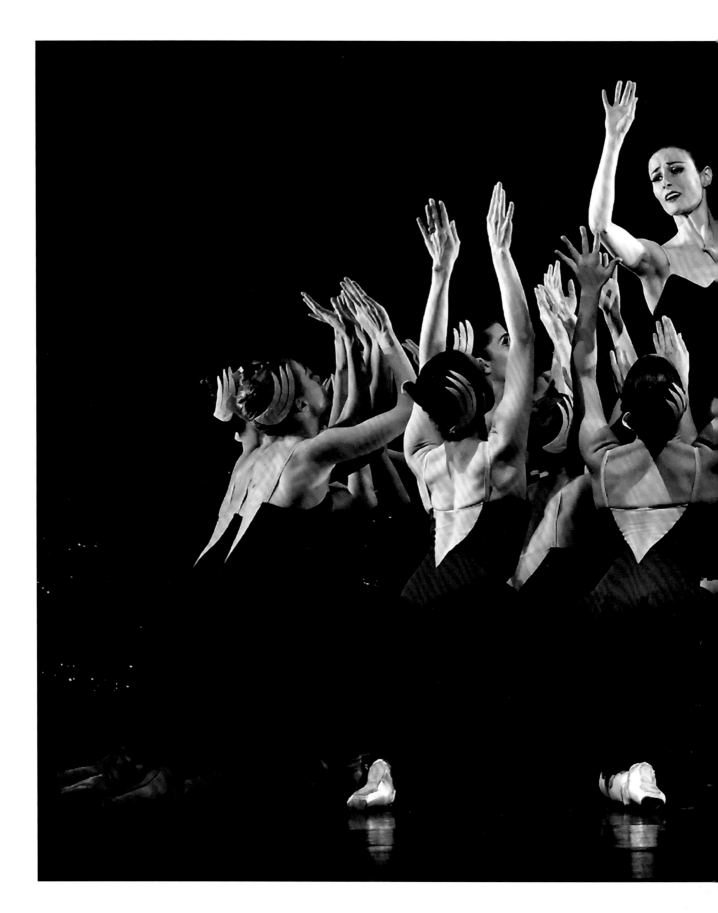

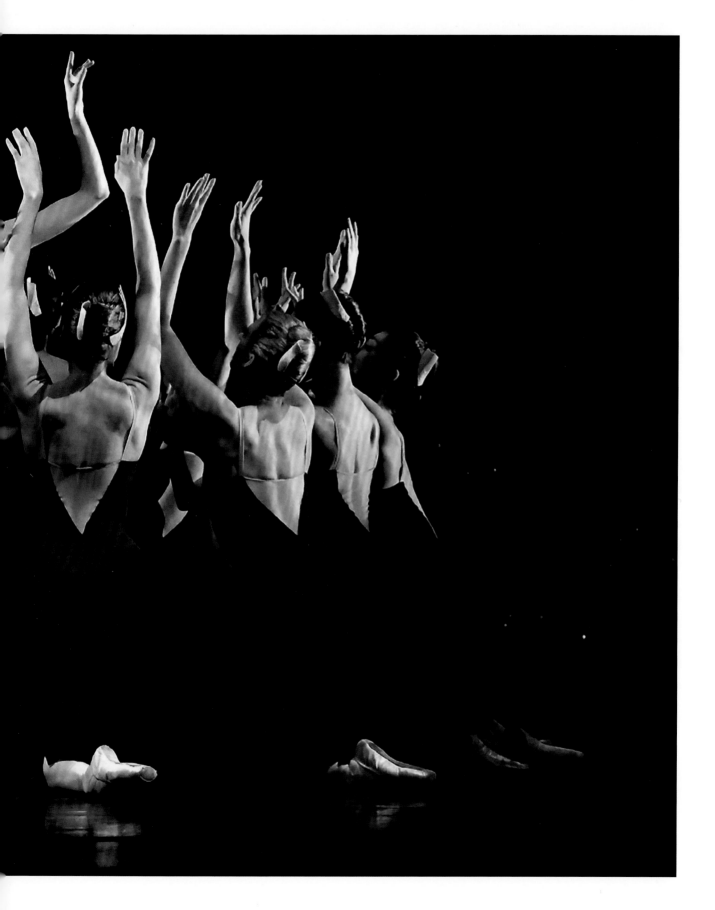

RIGHT
Semyon Chudin and Olga Smirnova
in Jean-Christophe Maillot's *The Taming of the Shrew*, performed by the Bolshoi Ballet at the Royal Opera House, Covent Garden, London
3 August 2016

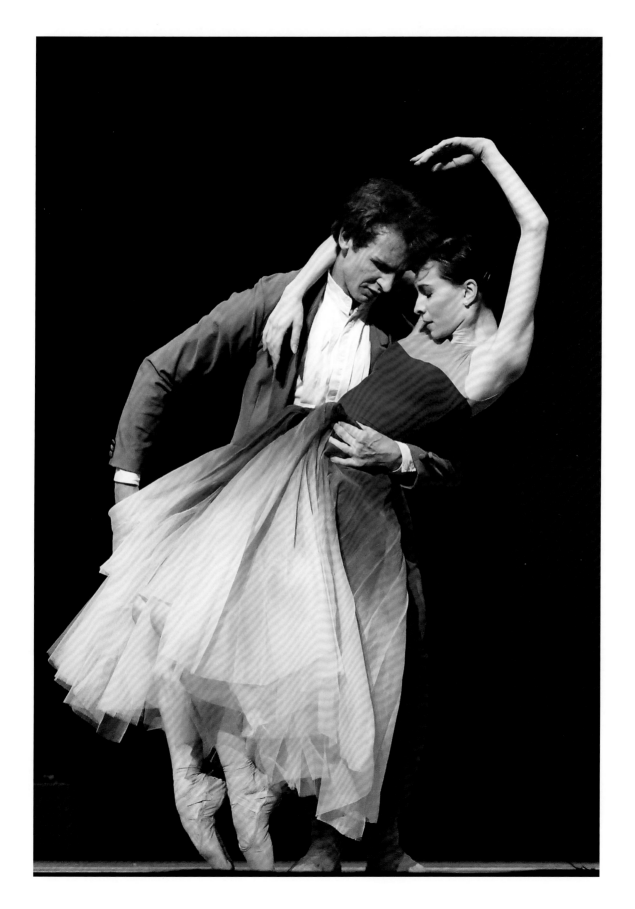

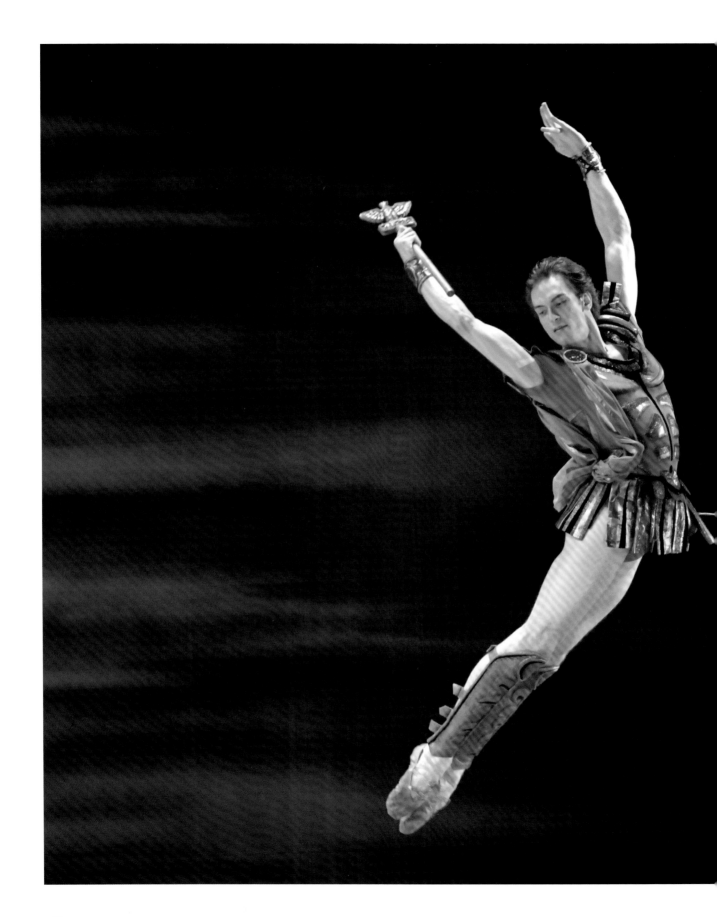

LEFT
Artemy Belyakov in Yuri Grigorovich's
Spartacus, performed by the Bolshoi
Ballet at the Royal Opera House, Covent
Garden, London
29 July 2019

Anastasia Denisova in Yuri Grigorovich's
Spartacus, performed by the Bolshoi
Ballet at the Royal Opera House, Covent
Garden, London
29 July 2019

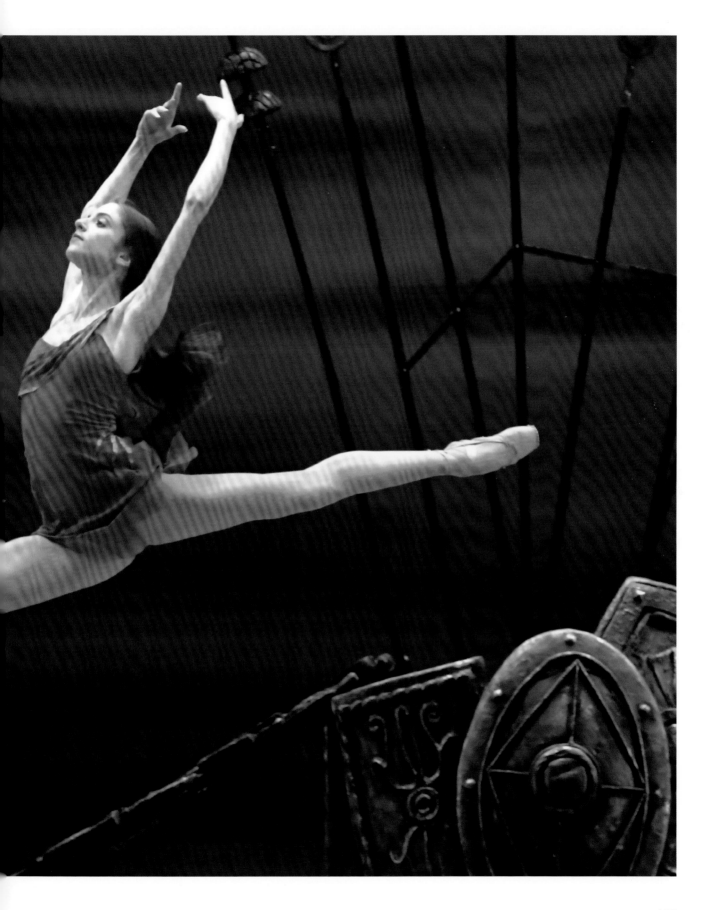

Ruslan Skvortsov and Ekaterina Shipulina
in Yuri Grigorovich's *Spartacus*, performed by
the Bolshoi Ballet at the Royal Opera House,
Covent Garden, London
29 July 2019

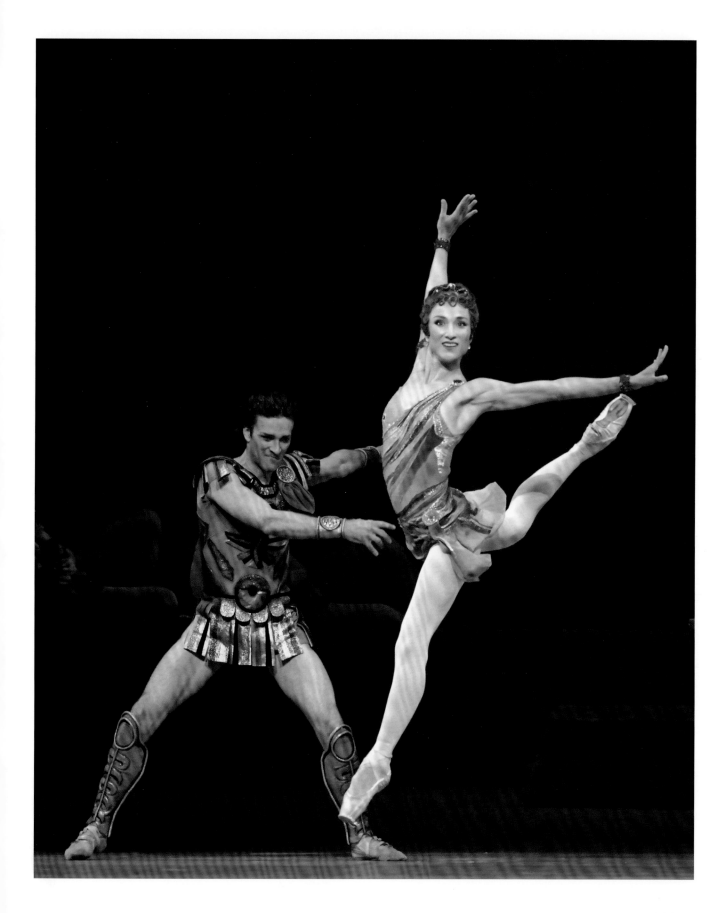

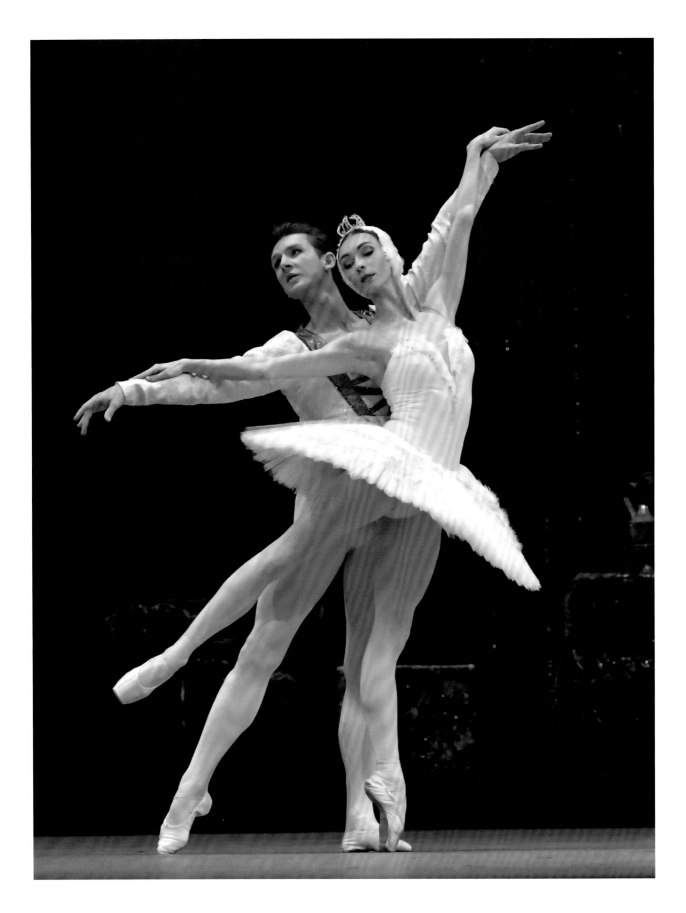

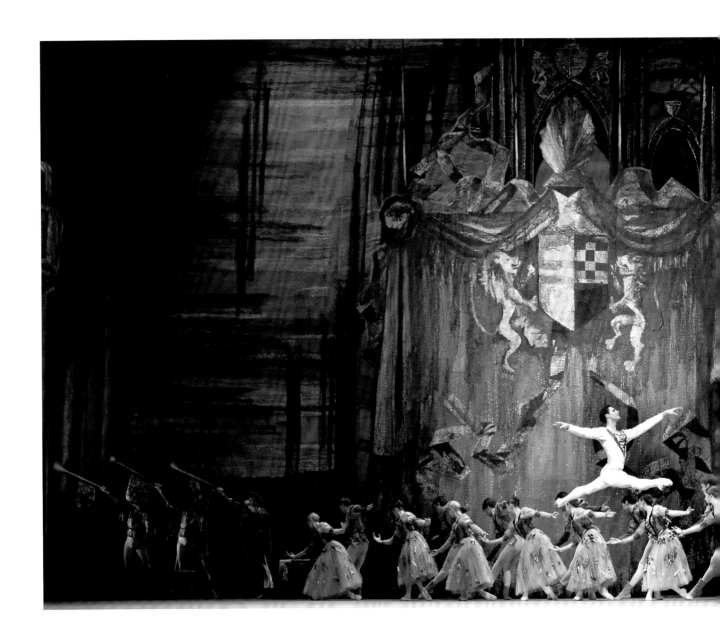

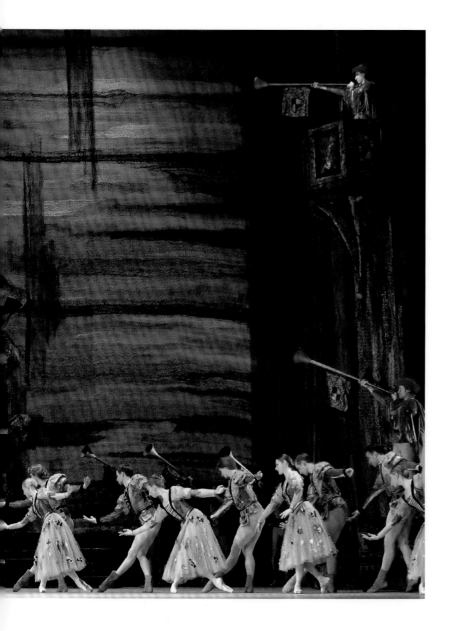

Jacopo Tissi in Yuri Grigorovich's *Swan Lake*, performed by the Bolshoi Ballet at the Royal Opera House, Covent Garden, London 2 August 2019

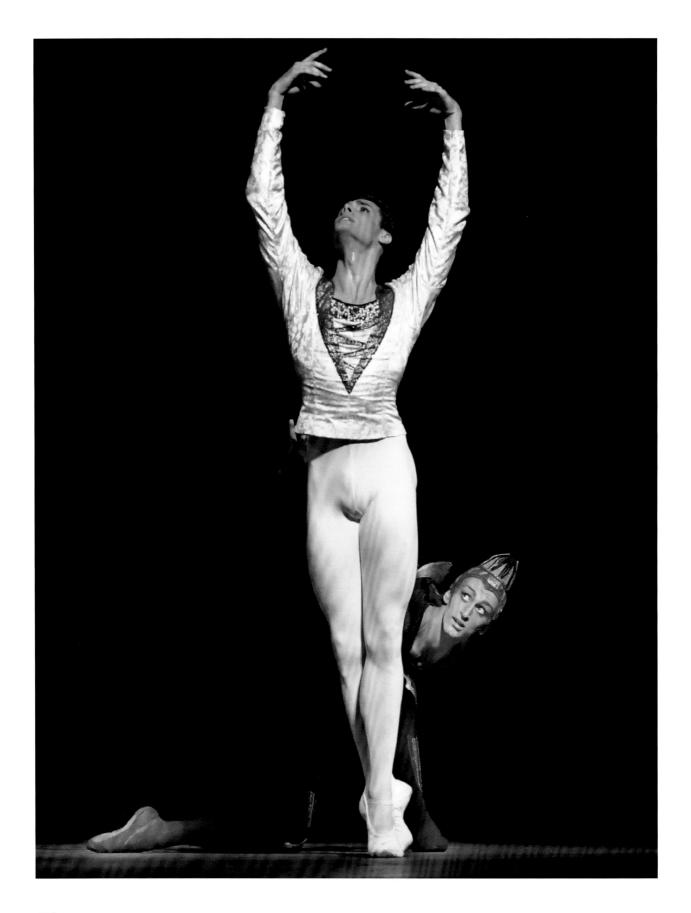

LEFT
Jacopo Tissi and Egor Gerashchenko in
Yuri Grigorovich's *Swan Lake*, performed by
the Bolshoi Ballet at the Royal Opera House,
Covent Garden, London
2 August 2019

RIGHT
Alyona Kovalyova in Yuri Grigorovich's
Swan Lake, performed by the Bolshoi
Ballet at the Royal Opera House, Covent
Garden, London
2 August 2019

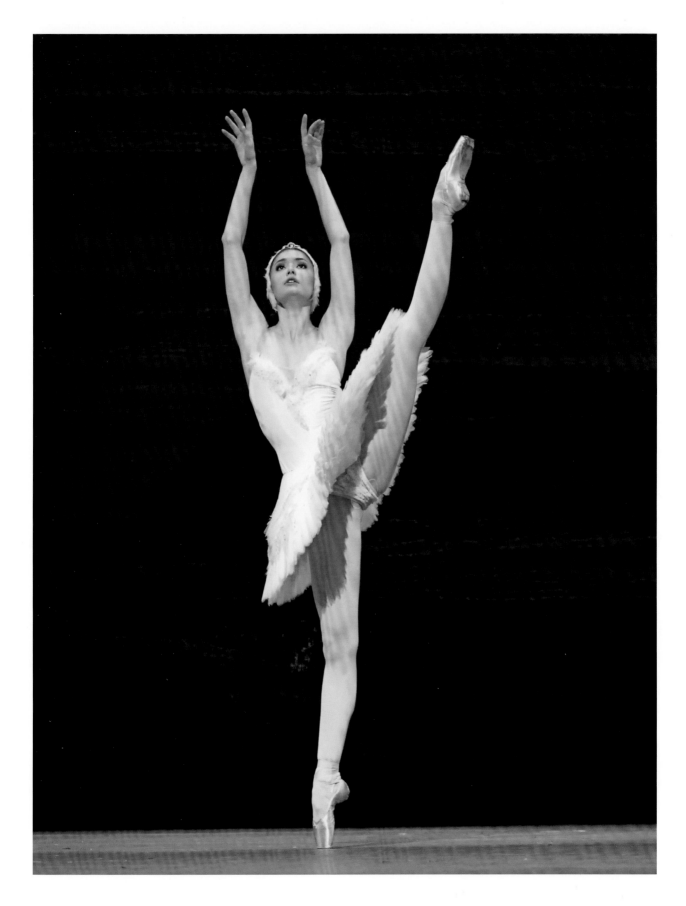

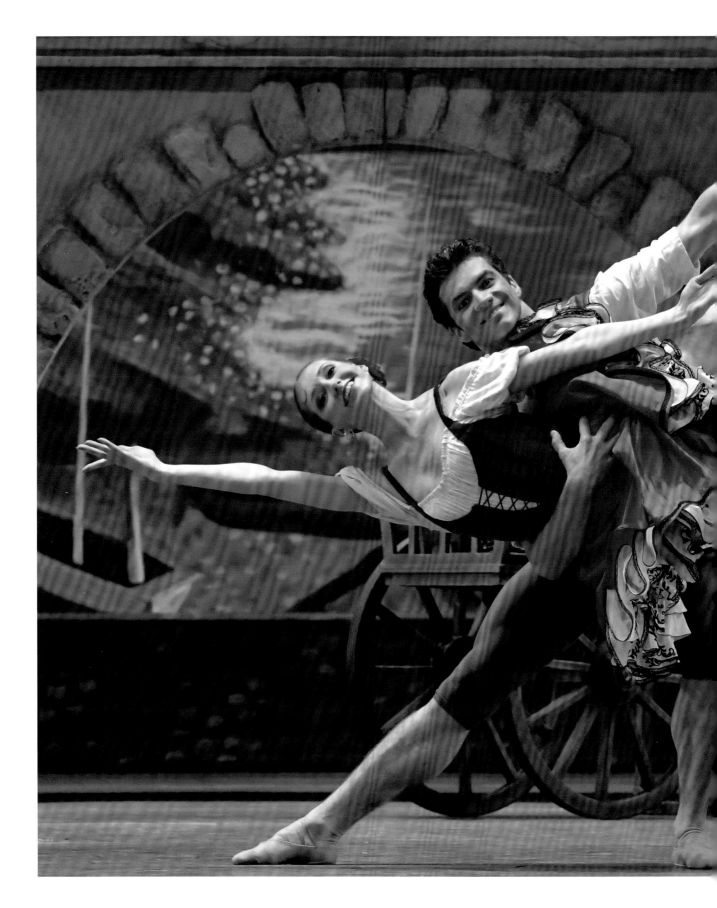

LEFT
Margarita Shrainer and Igor Tsvirko
in Alexei Fadeyechev's *Don Quixote*,
performed by the Bolshoi Ballet at the Royal
Opera House, Covent Garden, London
15 August 2019

Eleonora Sevenard in Alexei Fadeyechev's
Don Quixote, performed by the Bolshoi
Ballet at the Royal Opera House, Covent
Garden, London
15 August 2019

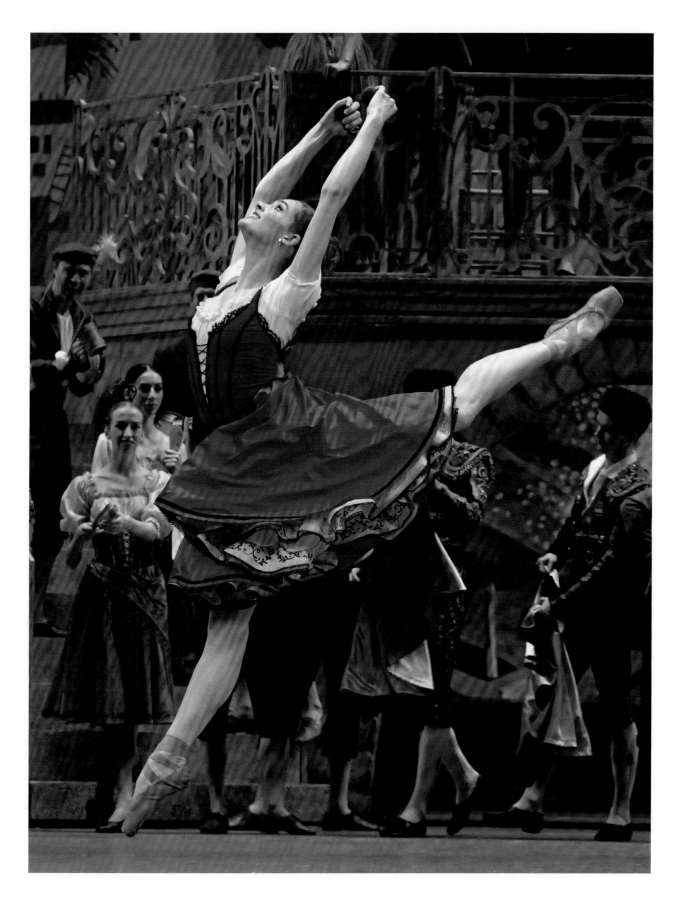

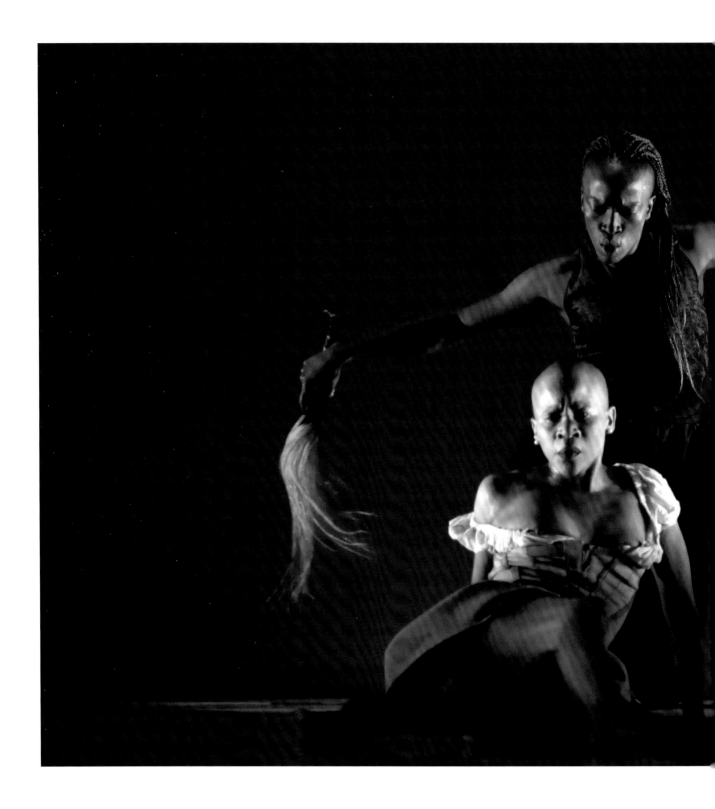

LEFT
Llewellyn Mnguni and Dada Masilo
in Dada Masilo's *Giselle*, performed by
Masilo's company at Sadler's Wells, London
4 October 2019

FOLLOWING PAGES
Llewellyn Mnguni in Dada Masilo's *Giselle*,
performed by Masilo's company at Sadler's
Wells, London
4 October 2019

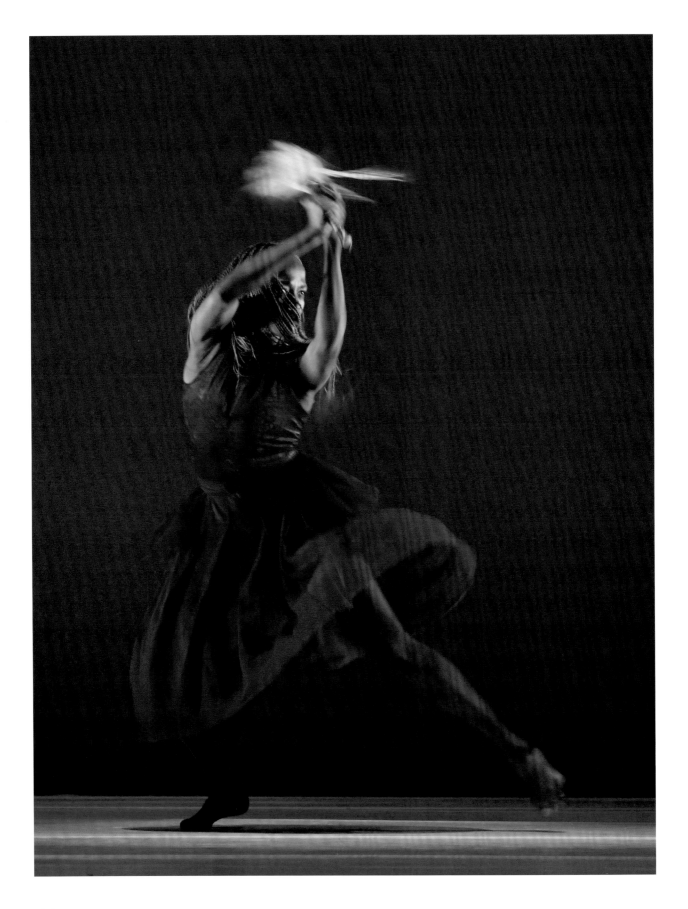

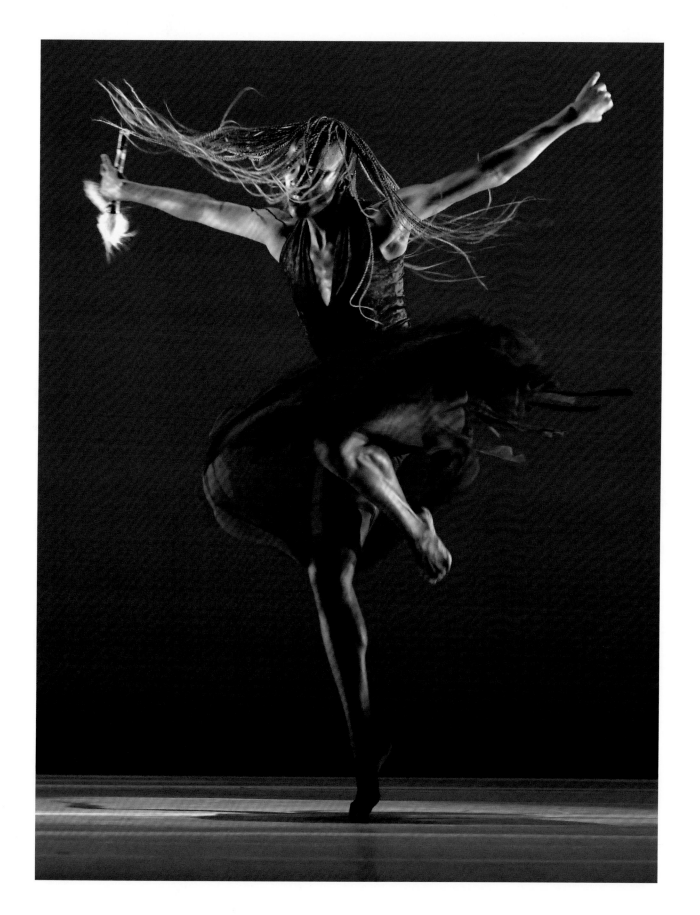

Technical details

Page 9
Lens: 162 mm
Shutter speed: 1/25
Aperture: f/4
ISO: 2000

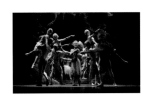

Pages 12–13
Lens: 116 mm
Shutter speed: 1/320
Aperture: f/3.2
ISO: 2000

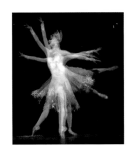

Page 15
Lens: 125 mm
Shutter speed: 1/160
Aperture: f/3.2
ISO: 1600

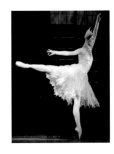

Page 16
Lens: 130 mm
Shutter speed: 1/160
Aperture: f/3.2
ISO: 1600

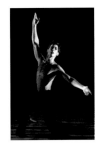

Page 19
Lens: 200 mm
Shutter speed: 1/60
Aperture: f/3.2
ISO: 3200

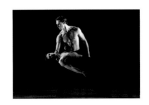

Pages 20–1
Lens: 180 mm
Shutter speed: 1/50
Aperture: f/3.5
ISO: 3200

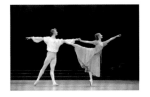

Pages 22–3
Lens: 102 mm
Shutter speed: 1/200
Aperture: f/3.2
ISO: 1600

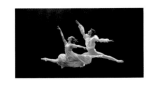

Pages 24–5
Lens: 110 mm
Shutter speed: 1/200
Aperture: f/3.2
ISO: 1600

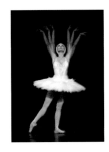

Page 26
Lens: 190 mm
Shutter speed: 1/100
Aperture: f/3.2
ISO: 1000

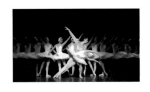

Pages 28–9
Lens: 105 mm
Shutter speed: 1/100
Aperture: f/3.2
ISO: 1000

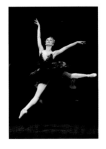

Page 33
Lens: 170 mm
Shutter speed: 1/200
Aperture: f/3.2
ISO: 1600

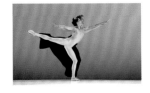

Pages 34–5
Lens: 140 mm
Shutter speed: 1/250
Aperture: f/3.2
ISO: 1600

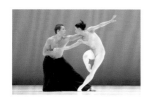

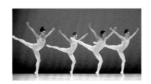

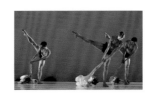

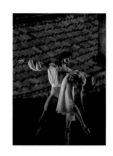

Pages 36–7
Lens: 116 mm
Shutter speed: 1/250
Aperture: f/3.2
ISO: 1600

Pages 38–9
Lens: 95 mm
Shutter speed: 1/250
Aperture: f/3.2
ISO: 1600

Pages 40–1
Lens: 86 mm
Shutter speed: 1/125
Aperture: f/3.2
ISO: 1600

Page 43
Lens: 140 mm
Shutter speed: 1/125
Aperture: f/3.5
ISO: 2500

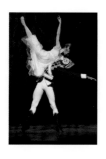

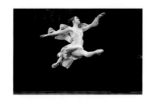

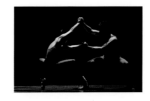

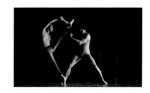

Page 44
Lens: 174 mm
Shutter speed: 1/200
Aperture: f/3.2
ISO: 2000

Pages 46–7
Lens: 135 mm
Shutter speed: 1/200
Aperture: f/3.2
ISO: 2000

Pages 48–9
Lens: 155 mm
Shutter speed: 1/80
Aperture: f/3.2
ISO: 2000

Pages 50–1
Lens: 170 mm
Shutter speed: 1/60
Aperture: f/3.2
ISO: 2000

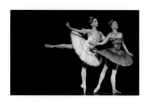

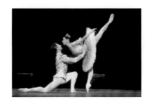

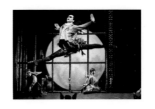

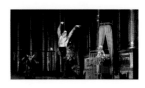

Pages 52–3
Lens: 155 mm
Shutter speed: 1/250
Aperture: f/4
ISO: 3200

Pages 54–5
Lens: 125 mm
Shutter speed: 1/250
Aperture: f/4
ISO: 3200

Pages 56–7
Lens: 105 mm
Shutter speed: 1/125
Aperture: f/3.2
ISO: 4000

Pages 58–9
Lens: 70 mm
Shutter speed: 1/125
Aperture: f/3.2
ISO: 4000

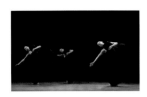

Pages 60–1
Lens: 102 mm
Shutter speed: 1/200
Aperture: f/4
ISO: 2500

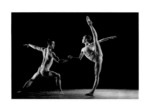

Pages 64–5
Lens: 116 mm
Shutter speed: 1/250
Aperture: f/4
ISO: 2500

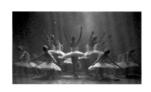

Pages 66–7
Lens: 65 mm
Shutter speed: 1/640
Aperture: f/4
ISO: 2000

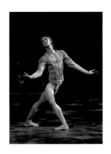

Page 69
Lens: 240 mm
Shutter speed: 1/320
Aperture: f/3.2
ISO: 2000

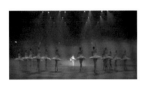

Pages 70–71
Lens: 32 mm
Shutter speed: 1/80
Aperture: f/4
ISO: 2000

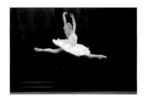

Pages 72–3
Lens: 135 mm
Shutter speed: 1/250
Aperture: f/4.5
ISO: 250

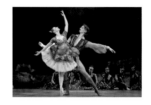

Pages 74–5
Lens: 135 mm
Shutter speed: 1/250
Aperture: f/4.5
ISO: 6400

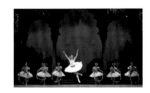

Pages 76–7
Lens: 57 mm
Shutter speed: 1/100
Aperture: f/4
ISO: 1250

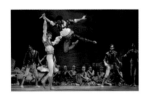

Pages 78–9
Lens: 105 mm
Shutter speed: 1/250
Aperture: f/4.5
ISO: 6400

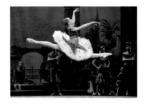

Pages 82–3
Lens: 150 mm
Shutter speed: 1/500
Aperture: f/4.5
ISO: 3200

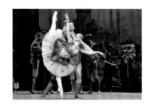

Pages 84–5
Lens: 135 mm
Shutter speed: 1/320
Aperture: f/4.5
ISO: 3200

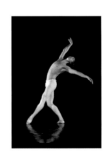

Page 87
Lens: 156 mm
Shutter speed: 1/160
Aperture: f/3.5
ISO: 4000

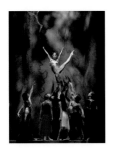

Page 88
Lens: 70 mm
Shutter speed: 1/160
Aperture: f/2.8
ISO: 4000

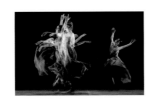

Pages 90–1
Lens: 78 mm
Shutter speed: 1/160
Aperture: f/5
ISO: 4000

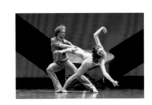

Pages 92–3
Lens: 155 mm
Shutter speed: 1/200
Aperture: f/4.5
ISO: 2500

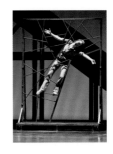

Page 94
Lens: 174 mm
Shutter speed: 1/200
Aperture: f/4.5
ISO: 2500

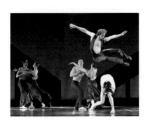

Pages 96–7
Lens: 85 mm
Shutter speed: 1/160
Aperture: f/4.5
ISO: 2500

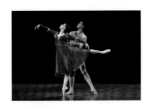

Pages 98–9
Lens: 155 mm
Shutter speed: 1/800
Aperture: f/4
ISO: 4000

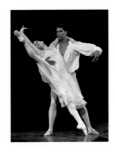

Page 101
Lens: 135 mm
Shutter speed: 1/400
Aperture: f/4.5
ISO: 4000

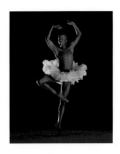

Page 102
Lens: 165 mm
Shutter speed: 1/160
Aperture: f/3.2
ISO: 2000

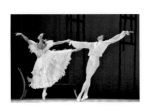

Pages 104–5
Lens: 150 mm
Shutter speed: 1/400
Aperture: f/4
ISO: 4000

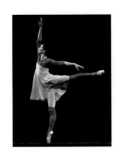

Page 107
Lens: 145 mm
Shutter speed: 1/640
Aperture: f/4
ISO: 4000

Page 109
Lens: 70 mm
Shutter speed: 1/160
Aperture: f/4.5
ISO: 2500

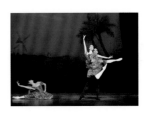

Pages 110–11
Lens: 95 mm
Shutter speed: 1/160
Aperture: f/4.5
ISO: 2500

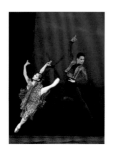

Page 112
Lens: 95 mm
Shutter speed: 1/160
Aperture: f/4.5
ISO: 2500

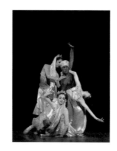

Page 115
Lens: 145 mm
Shutter speed: 1/125
Aperture: f/4.5
ISO: 2500

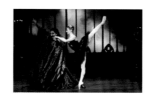

Pages 118–19
Lens: 130 mm
Shutter speed: 1/250
Aperture: f/4.5
ISO: 4000

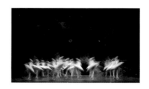

Pages 120–1
Lens: 32 mm
Shutter speed: 1/5
Aperture: f/4
ISO: 400

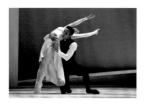

Pages 122–3
Lens: 190 mm
Shutter speed: 1/320
Aperture: f/4.5
ISO: 4000

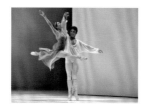

Pages 124–5
Lens: 145 mm
Shutter speed: 1/400
Aperture: f/3.5
ISO: 4000

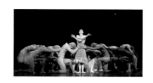

Pages 126–7
Lens: 90 mm
Shutter speed: 1/200
Aperture: f/5.6
ISO: 4000

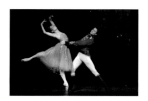

Pages 128–9
Lens: 110 mm
Shutter speed: 1/320
Aperture: f/5.6
ISO: 4000

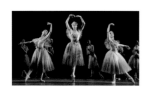

Pages 130–1
Lens: 110 mm
Shutter speed: 1/100
Aperture: f/5.6
ISO: 4000

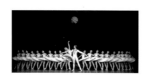

Pages 132–3
Lens: 48 mm
Shutter speed: 1/250
Aperture: f/5
ISO: 4000

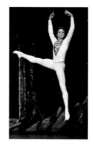

Page 135
Lens: 200 mm
Shutter speed: 1/400
Aperture: f/5
ISO: 4000

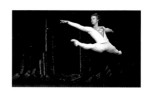

Pages 136–7
Lens: 112 mm
Shutter speed: 1/400
Aperture: f/5
ISO: 4000

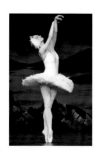

Page 138
Lens: 200 mm
Shutter speed: 1/400
Aperture: f/5
ISO: 4000

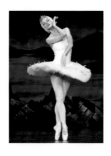

Page 139
Lens: 200 mm
Shutter speed: 1/400
Aperture: f/5
ISO: 4000

Pages 142–3
Lens: 70 mm
Shutter speed: 1/20
Aperture: f/4.5
ISO: 4000

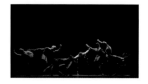

Pages 144–5
Lens: 120 mm
Shutter speed: 1/40
Aperture: f/4.5
ISO: 4000

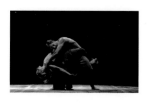

Pages 146–7
Lens: 135 mm
Shutter speed: 1/60
Aperture: f/4.5
ISO: 4000

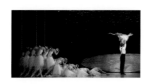

Pages 148–9
Lens: 48 mm
Shutter speed: 1/400
Aperture: f/4
ISO: 4000

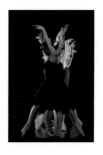

Page 151
Lens: 86 mm
Shutter speed: 1/25
Aperture: f/5.6
ISO: 4000

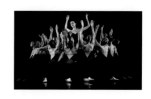

Pages 152–3
Lens: 80mm
Shutter speed: 1/60
Aperture: f/2.8
ISO: 4000

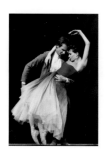

Page 155
Lens: 150 mm
Shutter speed: 1/4000
Aperture: f/4
ISO: 4000

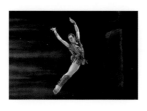

Pages 156–7
Lens: 138 mm
Shutter speed: 1/400
Aperture: f/3.2
ISO: 4000

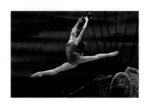

Pages 158–9
Lens: 183 mm
Shutter speed: 1/800
Aperture: f/3.5
ISO: 6400

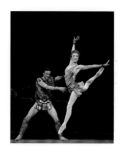

Page 161
Lens: 165 mm
Shutter speed: 1/1600
Aperture: f/3.5
ISO: 6400

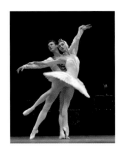

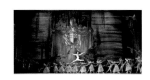

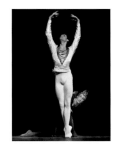

Page 162
Lens: 168 mm
Shutter speed: 1/2500
Aperture: f/3.5
ISO: 5000

Pages 164–5
Lens: 44 mm
Shutter speed: 1/400
Aperture: f/3.2
ISO: 5000

Page 166
Lens: 127 mm
Shutter speed: 1/500
Aperture: f/3.5
ISO: 5000

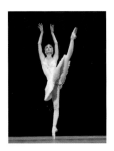

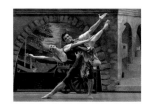

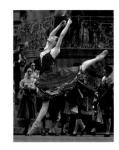

Page 169
Lens: 157 mm
Shutter speed: 1/320
Aperture: f/4.5
ISO: 5000

Pages 170–1
Lens: 165 mm
Shutter speed: 1/1000
Aperture: f/5
ISO: 2500

Page 173
Lens: 112 mm
Shutter speed: 1/1250
Aperture: f/5
ISO: 2500

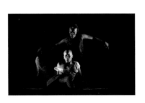

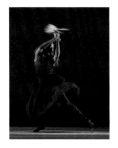

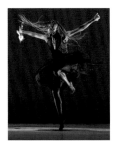

Pages 174–5
Lens: 202 mm
Shutter speed: 1/250
Aperture: f/2.8
ISO: 2000

Page 176
Lens: 153 mm
Shutter speed: 1/60
Aperture: f/8
ISO: 2000

Page 177
Lens: 135 mm
Shutter speed: 1/320
Aperture: f/3.5
ISO: 2000

INDEX

A

Acosta, Carlos 2, 98–9, 101
Acosta, Yonah 78–9, 110–11, 112
Andreyeva, Lyubov 92–3, 96–7
Araújo, Grey 9
Artifact (William Forsythe) 48–9, 50–1
Ashton, Frederick
 Marguerite and Armand 104–5
Ashton, Frederick
 Romeo and Juliet 43
Australian Ballet, The
 Swan Lake (Graeme Murphy) 148–9, 151, 152–3

B

Ballets de Monte-Carlo, Les
 Romeo and Juliet (Jean-Christophe Maillot) 122–3, 124–5
Belyakov, Artemy 156–7
Bolshoi Ballet, The
 Don Quixote (Alexei Fadeyechev) 170–1, 173
 Romeo and Juliet (Sir Frederick Ashton) 43
 Spartacus (Yuri Grigorovich) 156–7, 158–9, 161
 Swan Lake (Yuri Grigorovich) 162, 164–5, 166, 169
 Taming of the Shrew, The (Jean-Christophe Maillot) 155
Bourne, Matthew
 Sleeping Beauty 56–7, 58–9
Bull, Adam 148–9

C

Chudin, Semyon 155, 162
Cinderella (Alexei Ratmansky) 107
Cinderella (Christopher Wheeldon) 126–7, 128–9
Cojocaru, Alina 72–3, 74–5, 109, 118–19
Corder, Michael
 The Snow Queen 12–13, 15, 16
Corsaire, Le (Anna-Marie Holmes) 72–3, 74–5, 76–7, 78–9, 82–3, 84–5
Corso, Andressa 9
Costa, Crystal 110–11, 112

D

Deane, Derek
 Romeo and Juliet 2, 98–9, 101
 Swan Lake 26, 28–9, 33, 66–7, 69, 70–1, 118–19, 120–1
Denisova, Anastasia 158–9

Don Quixote (Alexei Fadeyechev) 170–1, 173
Dust (Akram Khan) 142–3, 144–5
Dutch National Ballet
 Cinderella (Christopher Wheeldon) 126–7, 128–9
 Grosse Fuge (Hans van Manen) 34–5, 36–7, 38–9, 40–1
 Hans van Manen – Master of Dance 34–5, 36–7, 38–9, 40–1
Dynott, Shevelle 115

E

Eagling, Wayne
 Men Y Men 19, 20–1
 Nutcracker 44, 46–7, 109, 110–11, 112, 115
Ecstasy and Death 60–1, 64–5
Eifman Ballet
 Rodin, Her Eternal Idol (Boris Eifman) 92–3, 94, 96–7
Eifman, Boris
 Rodin, Her Eternal Idol 92–3, 94, 96–7
English National Ballet
 Corsaire, Le (Anna-Marie Holmes) 72–3, 74–5, 76–7, 78–9, 82–3, 84–5
 Dust (Akram Khan) 142–3, 144–5
 Firebird (George Williamson) 88
 Lest We Forget 88, 90–1, 142–3, 144–5, 146–7
 Men Y Men (Wayne Eagling) 19, 20–1
 No Man's Land (Liam Scarlett) 90–1
 Nutcracker (Wayne Eagling) 44, 46–7, 109, 110–11, 112, 115
 Petite Mort (Jiří Kylián) 60–1, 64–5
 Romeo and Juliet (Derek Deane) 2, 98–9, 101
 Romeo and Juliet (Rudolf Nureyev) 22–3, 24–5
 Second Breath (Russell Maliphant) 146–7
 Sleeping Beauty, The (Sir Kenneth MacMillan) 52–3, 54–5
 Snow Queen, The (Michael Corder) 12–13, 15, 16
 Swan Lake (Derek Deane) 26, 28–9, 33, 66–7, 69, 70–1, 118–19, 120–1

F

Fadeyechev, Alexei
 Don Quixote 170–1, 173
Firebird (George Williamson) 88
Forbat, James 64–5
Forsythe, William
 Artifact 48–9, 50–1

G

Gabyshev, Oleg 92–3, 94, 96–7
Gerashchenko, Egor 166
Giselle (Dada Masilo) 174–5, 176, 177
Golding, Matthew 34–5, 40–1, 128–9
Grigorovich, Yuri
 Spartacus 156–7, 158–9, 161
 Swan Lake 162, 164–5, 166, 169
Grosse Fuge (Hans van Manen) 34–5, 36–7, 38–9, 40–1
Grupo Corpo
 Parabelo (Rodrigo Pederneiras) 9
Gumba, Yuri
 Swan Lake 132–3, 135, 136–7, 138, 139

H

Hans van Manen – Master of Dance 34–5, 36–7, 38–9, 40–1
Harrington, Jennie 115
Holmes, Anna-Marie
 Corsaire, Le 72–3, 74–5, 76–7, 78–9, 82–3, 84–5
Hudson, Anjuli 110–11

J

Jongh, Igone de 34–5, 40–1, 38–9

K

Khan, Akram
 Dust 142–3, 144–5
Kim, Lina 130–1
Klimentová, Daria 12–13, 15, 16, 22–3, 24–5, 26, 28–9, 33, 44, 52–3
Kolesnikova, Irina 138, 139
Kovalyova, Alyona 169
Kraus, Daniel 19
Kundi, Sarah 115
Kylián, Jiří
 Petite Mort 60–1, 64–5

L

Lest We Forget 88, 90–1, 142–3, 144–5, 146–7
Lopez, Marisa 38–9, 40–1
Lukovkin, Anton 20–1

M

MacMillan, Kenneth
 The Sleeping Beauty 52–3, 54–5
Maillot, Jean-Christophe
 Romeo and Juliet 122–3, 124–5
 The Taming of the Shrew 155
Maliphant, Russell
 Second Breath 146–7
van Manen, Hans
 Grosse Fuge 34–5, 36–7, 38–9, 40–1
Marguerite and Armand (Sir Frederick Ashton) 104–5
Mariinsky Ballet, The
 Cinderella (Alexei Ratmansky) 107
 Marguerite and Armand (Sir Frederick Ashton) 104–5
Marney, Christopher 56–7
Masilo, Dada 174–5
 Giselle 174–5, 176, 177
 Swan Lake 102
Men in Motion (Ivan Putrov) 4, 87
Men Y Men (Wayne Eagling) 19, 20–1
Mnguni, Llewellyn 102, 174–5, 176, 177
Morehen, Clare 130–1
Mower, Liam 58–9
Muntagirov, Vadim 4, 22–3, 24–5, 28–9, 54–5, 69, 74–5, 78–9, 87,
Murphy, Graeme
 Swan Lake 148–9, 151, 152–3

N

New Adventures
 Sleeping Beauty (Matthew Bourne) 56–7, 58–9
No Man's Land (Liam Scarlett) 90–1
Nureyev, Rudolf
 Romeo and Juliet 22–3, 24–5
Nutcracker (Wayne Eagling) 44, 46–7, 109, 110–11, 112, 115

O

Oliveira, George 122–3
Osipova, Natalia 43
Ovsyanick, Ksenia 46–7, 64–5, 82–3, 88

P

Pantastico, Noelani 122–3, 124–5

Parabelo (Rodrigo Pederneiras) 9
Pederneiras, Rodrigo
 Parabelo 9
Petite Mort (Jiří Kylián) 60–1, 64–5
Postlewaite, Lucien 124–5
Putrov, Ivan
 Men in Motion 4, 87

Q
Queensland Ballet
 Sylphide, La (Peter Schaufuss) 130–1

R
Reimair, Fabian 109
Ratmansky, Alexei
 Cinderella 107
Rodin, Her Eternal Idol (Boris Eifman) 92–3, 94, 96–7
Rodkin, Denis 135, 136–7
Rojo, Tamara 2, 52–3, 54–5, 98–9, 101, 144–5
Romeo and Juliet (Derek Deane) 2, 98–9, 101
Romeo and Juliet (Jean-Christophe Maillot) 122–3, 124–5
Romeo and Juliet (Rudolf Nureyev) 22–3, 24–5
Romeo and Juliet (Sir Frederick Ashton) 43
Royal Ballet Flanders
 Artifact (William Forsythe) 48–9, 50–1

S
Saito, Aki 48–9, 50–1
Scarlett, Liam
 No Man's Land 90–1
Schaufuss, Peter
 Sylphide, La 130–1
Schaufuss, Tara 130–1
Scott, Amber 148–9, 152–3
Second Breath (Russell Maliphant) 146–7
Sevenard, Eleonora 173
Shipulina, Ekaterina 161
Shrainer, Margarita 170–1
Skvortsov, Ruslan 161
Sleeping Beauty (Matthew Bourne) 56–7, 58–9
Sleeping Beauty, The (Sir Kenneth MacMillan) 52–3, 54–5
Smirnova, Olga 155, 162
Snow Queen, The (Michael Corder) 12–13, 15, 16
Souza, Junor 44

Spartacus (Yuri Grigorovich) 156–7, 158–9, 161
St Petersburg Ballet Theatre
 Swan Lake (Yuri Gumba) 132–3, 135, 136–7, 138, 139
Stott, Tamarin 115
Streeter, James 118–19, 144–5, 109
Summerscales, Laurretta 84–5
Swan Lake (Derek Deane) 26, 28–9, 33, 66–7, 69, 70–1,
 118–19, 120–1
Swan Lake (Yuri Grigorovich) 162, 164–5, 166, 169
Swan Lake (Yuri Gumba) 132–3, 135, 136–7, 138, 139
Swan Lake (Dada Masilo) 102
Swan Lake (Graeme Murphy) 148–9, 151, 152–3
Sylphide, La (Peter Schaufuss) 130–1

T
Takahashi, Erina 76–7
Taming of the Shrew, The (Jean-Christophe Maillot) 155
Tissi, Jacopo 164–5, 166
Tsvirko, Igor 170–1
Tsygankova, Anna 38–9, 126–7, 36–7, 128–9

V
Vanlessen, Wim 48–9, 50–1
Varga, Jozef 40–1
Vargas, Arionel 84–5
Vasiliev, Ivan 43
Viheriäranta, Anu 38–9, 40–1
Vishneva, Diana 104–5, 107

W
Westwell, Max 20–1, 109
Wheeldon, Christopher
 Cinderella 126–7, 128–9
Williamson, George
 Firebird 88

Y
Ygnace, Cedric 40–1

Z
Zhembrovskyy, Alexander 36–7
Zverev, Konstantin 104–5

ABOUT THE AUTHOR

Leo Mason is a UK-based professional photographer, who specializes in dance and sports photography and is renowned for his multiple exposure technique.

Early in his career, Leo worked at the *Observer* and other national newspapers before forming the Split Second Photo Agency. He has spent the last 40 years photographing global sports events, including the Olympics, Winter Olympics, FIFA World Cup, Tour de France, Wimbledon and the Superbowl. His work has appeared in *Time*, *Newsweek*, *Sports Illustrated*, *Life*, *GQ*, *USA Today, L'Equipe*, *Stern* and *Paris-Match*.

Since 2009, Leo has photographed some of the world's best principal dancers and ballerinas, including Tamara Rojo, Carlos Acosta, Natalia Osipova, Vadim Muntagirov, Daria Klimentová and Ivan Vasiliev. He has shot on location at the UK's leading theatres, including the Royal Opera House, Sadler's Wells and the London Coliseum. He has also shot a variety of different styles of contemporary dance, including flamenco, hip hop and Argentinian tango.

He has lectured at Oxford University, Ireland's Press Association (in association with Nikon UK) and the Royal Photographic Society, of which he is an associate.

Leo's exhibition *The Coast Exposed* (in association with Magnum Photos and the National Trust), is on permanent display at the National Maritime Museum in Greenwich. He has also exhibited at the Lowry Museum, the Gherkin, the Royal Automobile Club and the Commonwealth Club. He is also a member of and has exhibited at the Chelsea Arts Club and he was chair of the club's exhibitions sub-committee for three years.

ACKNOWLEDGEMENTS

Leo Mason would like to thank the following for their assistance with this book:

Deborah Desmond-Hurst, Susan Dalgetty Ezra and Janet Radenkovic for their invaluable help with the captions.

Nikon UK for help with cameras and service.

Popperfoto and Getty Images for their kind permission to reproduce the photographs.

First published 2023 by
Ammonite Press
an imprint of Guild of Master Craftsman Publications Ltd
Castle Place, 166 High Street, Lewes,
East Sussex BN7 1XU
United Kingdom

Thanks to Bob Thomas at Popperfoto and to Getty Images for generously allowing the
images to be published in this book. Special thanks to Matthew Butson, Justyna Zarnowska,
Julian Ridgeway and Jon Wilton at the Getty Archive in London.

ISBN 9-781-78145-460-2

Publisher Jonathan Bailey
Production Director Jim Bulley
Design Manager Robin Shields
Editor Laura Paton

Colour origination by GMC Reprographics
Printed and bound in China

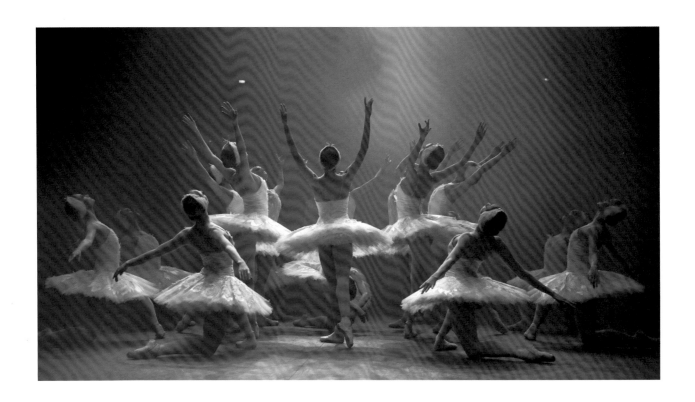

To order GMC books, please contact:
GMC Publications Ltd
Castle Place, 166 High Street,
Lewes, East Sussex,
BN7 1XU
United Kingdom
Tel: +44 (0)1273 488005
www.gmcbooks.com

AMMONITE
PRESS

www.ammonitepress.com